# Futures Past
## Thirty Years of Arts Computing
Computers and the History of Art, Volume Two

**Edited by**

**Anna Bentkowska-Kafel, Trish Cashen and Hazel Gardiner**

**intellect** Bristol, UK / Chicago, USA

First Published in the UK in 2007 by
Intellect Books, PO Box 862, Bristol BS99 1DE, UK
First Published in the USA in 2007 by
Intellect Books, The University of Chicago Press, 1427 E. 60th Street, Chicago, IL 60637, USA
Copyright © 2007 Intellect Ltd

A catalogue record for this book is available from the British Library.

ISBN 978-1-84150-168-0
ISSN 1743-3959
Cover Design: Gabriel Solomons
Copy Editor: Holly Spradling

Printed and bound by HSW Print, UK.

# Futures Past
## Thirty Years of Arts Computing

**Computers and the History of Art, Yearbook 2005, Volume 2**

Edited by Anna Bentkowska-Kafel, Trish Cashen and Hazel Gardiner

The papers by Pierre R. Auboiron, Sian Everitt, James Faure Walker, Andrew E. Hershberger, Colum Hourihane, Catherine Mason, Vickie O'Riordan, Melanie Rowntree and Matthias Weiss were originally presented at the CHArt conference held at Birkbeck College, Thursday 11 – Friday 12 November 2004 and are published online at www.chart.ac.uk/chart2004. Matthias Weiss's paper appears under the Creative Commons Licence 'Attribution NonCommercial-NoDerivs 2.0 Germany' http://creativecommons.org/licenses/by-nc-nd/2.0/de/ (November 2004).

The papers have been refereed by the CHArt Editorial Board and independent reviewers. CHArt wishes to thank Michael Allen and Patrizia Di Bello of Birkbeck College, London, UK; Paul Brown of the University of Sussex, UK; Irina Costache of the California State University Channel Islands, USA; Jim Devine of the Hunterian Museum in Glasgow, Scotland; Willard McCarty of King's College, London, UK; Heather Robson of Northumbria University, Newcastle, UK; Non Scantlebury of the Open University, UK; Christine Sundt of the journal *Visual Resources* and Wlodek Witek of the Norwegian National Library in Oslo for reviewing the papers. Their comments were communicated to the authors. A number of authors have responded to the reviewers' suggestions and enhanced the clarity of their arguments.

CHArt, Centre for Computing in the Humanities, King's College, Kay House, 7 Arundel Street, London WC2R 3DX. Tel: +44 (0)20 7848 2013, Fax: +44 (0)20 7848 2980, www.chart.ac.uk, publications@chart.ac.uk.

# Table of Contents

# Contributors

**Pierre Auboiron** is a Ph.D. student of Contemporary Art History at Panthéon-Sorbonne University in Paris. His research is concerned with light as a material in current artistic practices such as installations, videos, projections, architecture and theatre. Drawing on his interest in visual semiotics and his background in visual electrophysiology, he is currently writing a handbook of visual physiology for art history students.

**Anna Bentkowska-Kafel** is Imaging Officer for the Corpus of Romanesque Sculpture in Britain and Ireland (www.crsbi.ac.uk) and is responsible for the creation and long-term preservation of the project's digital archive. Her research, teaching and publications have been mainly on early modern visual culture in Western Europe, with special interest in cosmological and anthropomorphic representations of nature; as well as the use of digital imaging in iconographical analysis and interpretation of paintings. She has an MA in the History of Art (Warsaw), MA in Computing Applications for the History of Art (London) and Ph.D. in Digital Media Studies (Southampton). She has been a member of the CHArt committee since 1999.

**Luciana Bordoni** graduated in mathematics and specialised in Control System and Automatic Calculus Engineering at La Sapienza University of Rome. Since 1980, she has worked for ENEA (the Italian National Agency for New Technology, Energy and Environment) in Casaccia, Rome, in the field of data processing, databases and information handling. Currently she is UDA/Advisor for ENEA and aims to develop methods, techniques and systems that can contribute to innovations in the dissemination of information.

**Trish Cashen** has been involved with integrating computing into university-level humanities teaching since the early 1990s. She works at The Open University, where her role involves integrating new media into a blended environment for teaching arts subjects. Her main areas of interest lie in integrating computing into blended learning environments to deliver opportunities for resource discovery, formative assessment and communication. She has been a member of the CHArt committee since 1994.

**Sian Everitt** is Keeper of Archives at Birmingham Institute of Art and Design. She studied history with history of art at the University of Hull and obtained her MA in the History of Art and Design at the University of Central England. She has previously worked in the museum and gallery sector and was teaching art and design history in Further and Higher Education.

**James Faure Walker** is a British artist and author and has been Senior Research Fellow in Fine Art at Kingston University since 2002. He studied painting at St Martin's School of Art in London in the 1960s and aesthetics at the Royal College of Art in the early 1970s. In 1976 he founded *Artscribe* magazine and was its first editor. His works use both traditional and digital media. He has exhibited widely in Europe, the USA, Japan and Russia and has taken part in a number of computer art

events. In 1998 he won the 'Golden Plotter' prize in Germany. *'Painting the Digital River: How an Artist Learned to Love the Computer'* has been published by Prentice Hall in 2006.

**Hazel Gardiner** is Senior Project Officer for the AHRC ICT Methods Network, based at the Centre for Computing in the Humanities, King's College, London. Before joining CCH in May 2005, she was the Research Officer for the MA in Digital Art History at Birkbeck College and prior to this the Research Assistant for the Corpus of Romanesque Sculpture in Britain and Ireland (www.crsbi.ac.uk). She continues to work with the CRSBI and is a researcher for this project and also for the Corpus Vitrearum Medii Aevi (www.cvma.ac.uk). She also contributes to the Material Culture module of the MA in Digital Humanities at CCH. She has been a member of the CHArt committee since 1997.

**Andrew E. Hershberger** is Assistant Professor of Contemporary Art History, Bowling Green State University, Ohio. He received his Ph.D. from Princeton University in 2001. His teaching and research are concerned with the history of photography. He is currently working on a book entitled *Cinema of Stills: Minor White's Sequential Photography.*

**Colum P. Hourihane** received his Ph.D. from the Courtauld Institute of Art, University of London in 1984 for a study on the iconography of medieval Irish art which was subsequently published as *Gothic Art in Ireland 1169–1550* (Yale University Press, 2003). After working in the Institute for over thirteen years he became director of The Index of Christian Art, Princeton University in 1997, the post he still holds. He is also a director in the International Center for Medieval Art (The Cloisters, New York) and a Fellow of The Society of Antiquaries of London. His most recent publication is *The 'Dallye' Cross, The Processional Cross in Late Medieval England* (Society of Antiquaries, London, 2005).

**Catherine Mason** was the Ph.D. Candidate on the CACHe Project in the School of History of Art, Film and Visual Media, Birkbeck College, London (www.bbk.ac.uk/hafvm/cache/) funded by the Arts and Humanities Research Board. She is currently completing her thesis on the role of cultural institutions and artists' initiatives in the early period of British computer arts, from 1960 to 1980.

**Vickie O'Riordan** is the curator of the Visual Resources Collection at the University of California, San Diego, USA. She is a member of the Visual Resources Association and serves on the VRA Data Standards Committee.

**Melanie Rowntree** currently works as Documentation Officer in the Records Section at the Victoria and Albert Museum, London. This role involves the management and delivery of the Computer Information System (CIS) training programme and management of the CIS Helpdesk as well as content creation and accountability projects. She read Music at Manchester University and went on to gain an MA in the History of Art at Warwick University. She has recently been awarded an Associateship by the Museums Association.

**Jutta Vinzent** lectures in modern and contemporary art and visual culture at the Department of History of Art at the University of Birmingham, UK. She also specialises in migration studies, having published articles and books on the art of

refugees from Nazi Germany in Britain. She studied for her masters and doctorate in Germany at Munich and Cologne respectively and holds a Ph.D. from Cambridge University and a Postgraduate Certificate in Teaching in Higher Education from the University of Birmingham.

**Matthias Weiss** is a freelance art critic and art historian. He read Art History, German Literature and Philosophy at the Ruhr-University Bochum. The analysis of Samuel van Hoogstraten's *trompe l'oeil* paintings was the subject of his MA. He worked for a research project entitled Identity and Alterity, based at the University of Freiburg from 2000 to 2002 and is now completing his Ph.D. on Internet art.

# Introduction

## Trish Cashen

Most of the papers published in this volume were first presented at CHArt's twentieth annual conference, held at Birkbeck College, London, on 11–12 November 2004. To mark two decades of CHArt conferences, the chosen topic was 'Futures Past: Twenty years of arts computing'. Not surprisingly, many papers focused on past projects, highlighting the disparities now clearly visible between earlier visions of the future and present reality.

Some issues first raised as far back as the 1960s and 70s remain relevant to practice in the first decade of the twenty-first century. James Faure Walker's personal account of his artistic practice, 'Painting Digital, Letting Go' recounts the special status originally awarded to digital art, from 'the first clatterings' at *Cybernetic Serendipity*. He draws attention to the fairly routine integration of digital methods by many practising artists today, with reference to his own evolving practice, noting that digital art is still somehow regarded as 'special' – it has not been absorbed as just another technique available to artists. He argues that new methods might be employed more effectively if critics focused on the artistic quality of the end products as much as on how they had been produced.

Matthias Weiss in 'Microanalysis as a Means to Mediate Digital Arts' is similarly concerned to promote a better understanding of art produced by interventions with computing, but in contrast to Faure Walker, he focuses on examples of software art such as Georg Nees' *Schotter* and Alex MacLean's *Forkbomb*. Weiss argues for a more profound understanding of the techniques behind the production of digital art: whereas most art historians have a good grasp of the methods and practices associated with the production of more conventional art works, few are in a position to appreciate how a knowledge of the code which generates a digital artwork can amplify our understanding of it. Unlike Faure Walker, he wants computer art to retain a special status and to be studied with an awareness of computing methods.

Pierre Auboiron, while asserting that some artists use digital technologies in an ill-considered way, celebrates the successful partnerships between digital artists and architects. In 'Indexed Lights' he explores the contribution made by the projects of Toyo Ito and Kaoru Mende in Japan and Jean Nouvel and Yann Kersalé in France. The case studies demonstrate how a thoughtful use of digital technology can enhance both the urban environment and social spaces, contradicting popular misconceptions which associate computers with a cold and sanitised view of the world.

Catherine Mason's paper 'A Computer in the Art Room' traces the early development of computer art in the UK by examining the role played in the 1960s and 70s by art schools and polytechnics. She credits the resource arrangements at polytechnic colleges with facilitating fruitful collaborations between artists and technical staff and documents a range of seminal collaborative projects which continue to have far-reaching implications for contemporary practice.

One ubiquitous theme at CHArt 2004 was the fate of projects which had generated so much excitement at previous conferences, promising great advances but now apparently vanished without a trace. Happily, one project showcased at previous CHArt conferences – the Princeton Index of Christian Art – not only still survives but continues to flourish. It is represented here by a pair of complementary papers, one by its Director, Colum Hourihane, the other by Andrew Hershberger, a photographic historian who had worked on the Index. Hourihane's paper 'Sourcing the Index: Iconography and its debt to photography' considered how the Index had been forced to adapt first to using a database rather than manually produced index cards and, more recently, to enter a new phase as a resource available on the Internet. Hourihane characterises this change as essentially from being a passive repository to becoming an active publisher. While the benefits are indisputable, such a change inevitably poses many challenges to a project conceived when the most technologically advanced equipment employed was a photographic copy stand. The secret of the Index's continuing success lies in its ability to remain flexible enough to adapt to new methods.

Hershberger's paper, 'The Medium was the Method: Photography and iconography at the Index of Christian Art', investigates the role of one technology – photography – as an underlying model for the Index's methodology. He points to the general lack of self-awareness in the use of photography as an 'objective' source of information. It can also be argued that the photographs are in many ways more accessible and informative than any text entry; by providing detailed, high-quality visual information, photographs allow scholars more scope to pursue their interests directly. Hershberger's paper raises the question of how new technologies may impact on the Index's methodologies in the future.

Three papers describe case studies which highlight the importance of agreed standards in order to ensure continued access to shared resources. A focus on education and the dissemination of new methodologies is a primary concern of Vickie O'Riordan. Her paper, 'This is the Modern World: collaborating with ARTstor', describes the digitisation of a slide library as a collaborative project with ARTstor, a provider of digital images. This case study at the University of California, San Diego, shows how a variety of stakeholders had to learn to compromise and work together in order to bring about a successful outcome. It provides useful background on what can make or break a collaborative project, particularly one involving several stakeholders from different communities of practice.

Similarly, Melanie Rowntree in 'Successes and Failures in the Web Delivery of Object Information at the V&A' provides a frank and detailed account of a single large institution's repeated attempts to enhance their outreach programme by making materials available on the Web. Rowntree's paper traces the development of four major projects and, with the benefit of hindsight, identifies the decisions which made later repurposing of the data all but impossible. She proposes a project management process which combines good practice in content creation with closer management of communications between members of disparate teams.

Sian Everitt in 'The Good, the Bad and the Accessible: thirty years of using new technologies in BIAD Archives' provides a longer perspective on attempts to employ

new technologies to modernise the archive of a single institution. Her descriptions of a range of innovative but now defunct initiatives reinforce the need to develop strategies for digital preservation and migration at the initial planning and design stages.

The selection of conference presentations is supplemented here by two additional essays which resonate with the original themes but look more to the future than to the past. With the growing ubiquity of computing, particularly use of the Internet, projects which once would have been unthinkable have become commonplace.

Jutta Vinzent's paper 'Learning Resources for Teaching History of Art in Higher Education' describes a teaching pilot carried out in 2002. This evaluated students' reactions to the replacement of slides with PowerPoint presentations and made use of the Internet and departmental intranet to develop students' presentation and research skills. This case study illustrates what can be achieved by a single teacher working with fairly limited resources and points out the need to develop institutional mechanisms to support the use of ICT in teaching. As Vinzent notes, new technologies can be used not simply to enhance students' learning, but to introduce new ways of learning that are more student-centred and foster more independent study.

'Towards a Semantic Web: The role of ontologies in the literary domain' by Luciana Bordoni looks forward to how the Semantic Web will facilitate wider sharing of knowledge. Advances in the creation of research ontologies will allow users to search for items with a shared underlying meaning, rather than relying on precise word-matching. Although the case studies mentioned here are taken from the domain of literature, the requirement for subject experts and knowledge engineers to collaborate on the development of specific research ontologies holds good for any humanities discipline, and the methods described here could be applied beneficially to the study of art.

The pervasiveness of computing at the start of the twenty-first century will continue to provide new opportunities of society, not least in the creation and study of art. Perhaps the most exciting advancements hinted at in these papers are the ways in which communities of interest are developing shared resources and cultivating a richer use of common vocabulary to transmit an abundance of knowledge and experience.

# Painting Digital, Letting Go

## James Faure Walker

What is a painter (and in my case a digital painter) doing at a conference on computing and the history of art? The short answer is, I am as interested as anyone else in trying to understand this combustion of art fuelled by high technology, and, in part, it is my own history too. Along with my colleagues, I often wonder how I have arrived where I am, and wonder how many wrong turnings I have taken. Have I been tinkering on the edges while the important action has taken place over the hill? If histories are now becoming official, are they being dug out of cupboards, built out of theories, or drawn from the memory of witnesses? Do I see this as self-evident art history written in a sequence of major works, each deserving its marker at Tate Modern? No. Have I been programmed to think the way I do? Should I reboot my thinking in the light of new historical findings?

As a student at St Martin's School of Art in London in the 1960s, I watched here and there a few of the first clatterings of computer art: kinetic art at *Signals, Cybernetic Serendipity*,[1] Bruce Laccy (who was the janitor of my studio from 1971 onwards), and the beige card science/art pages of Studio. As a painter and critic in the 1970s, I was aware of computerised typesetting (I was editing and designing an art magazine) and instinctively knew this was something I should know much more about, though, generally, I did not rate 'computer art' as art, apart from Richard Hamilton's *Tyres*. In the 1980s, I half-evolved into a 'computer artist' but without ceasing to be a painter. Now, I suppose, I am something of a sleuth, being an Art and Humanities Research Board (AHRB) Research Fellow, both practitioner and commentator.

I know of several books in production and plenty on the shelves documenting the route to Net Art, Information Art, Digital Art, or New Media art. Naturally, I am curious as to how this history develops. Will it be contested? For one thing, painting does not feature very much in these accounts except as a 'technology' – that is to say, pigment on canvas – a technology past its prime. My impression is that here is a history that zeroes in on the beginnings of 'computer art'; it identifies pioneer figures, particularly those developing what are best described as 'computer-generated' images, primarily linear patterns. Yet if I reflect on who have been the dominant figures and the dominant topics of discussions over the past ten or fifteen years, I find much broader influences at work. Important as they are, algorithmic artists would feature only as one strain alongside performance art, video, installation, conceptual art, interactive technologies, the Web, the futurology of *Wired*, innovations in computer graphics itself, and contemporary art in general. In other words, in the small segment of all this that concerns me – painting with the computer – the history of machine art is only one fraction. In today's 'digital art' it is not possible to isolate just one history, one DNA signature.

The subject of painting and the computer is complex, little understood, and neglected. To put it simply, each new survey that comes out on 'digital art' has

an interest in saying, 'here is something new and distinct from the old order'. The thesis of the book I am writing, *Painting the Digital River, How an Artist Learned to Love the Computer*, argues that painting is a living, adaptable art form, and painters can weave these wonderful visual tricks into their repertoire.[2] Art historians may object to the notion and argue that a painter has no critical distance; they could point to the lack of highbrow magazine articles, proper exhibitions, the lack of sustained interest by critics. All this I would have to concede, but I would also ask how anyone could be expected to find out about this way of painting except by doing it themselves. You cannot investigate retrospectively what does not yet exist. There have been one or two minor surveys and there are networks of artists but that's about it. With software, as with painting, only a user can really taste the difference. It is not like a documented installation with photos in a catalogue or a promotional critical essay; material that can become instant history – what Hal Foster has described as 'hind sighting the present'. I have found it hard to get the basics of computer graphics across to colleagues who are critics and sophisticated thinkers – I wonder how many understand the difference between bitmap and vector, not that I am that good at explaining it. They will always counter my argument by saying, well, as there is no major art – as yet – in that field, we do not need to bother with it. But some do.

I recall a Courtauld art historian a couple of years back, supposedly an expert on the Web and a curator, giving a talk with 35mm slides at the Tate. I also recall a leading expert on avant-garde film who did not know what a website was. At a talk I gave six years ago at the Tate on Patrick Heron, a number of the audience were quite unaware that you could 'paint' with the computer in colour. I still find it bizarre that a technology which has so many echoes back and forth in the history of painting (which would have been sheer dreamland for any assistant slaving in a Florentine studio 500 years ago) means little to today's *cognoscenti*. There are advantages in having so few art historians and critics around with expert knowledge. It is liberating to work with a powerful technology where there are few precedents, few established idioms, and few tracks in the snow to follow. The downside is that prejudices go unchallenged; in the Jerwood Drawing competition, digital drawing has been effectively excluded on the grounds that it is printed and so is not 'real drawing'. It is only in the past few years that galleries have recognised that inkjet prints are viable and sellable. In the teaching of fine art, the computer room is still labelled with the catch-all 'media', which these days means predominantly video editing. So this marvellous instrument often remains segregated and underused – though not for long, I hope.

What do I mean by liberating? In part, I am thinking practically of the speed of response, the immediacy, the ability to catch an idea while it is still in flight. For years I have had a digital camera in my bag, and in moments I am able to capture an image from a bus, or move between liquid and digital paint, or process a mark through a filter, a colour correction, a pattern. As I work with these 'instruments' every day, their use increasingly becomes second nature to me.

Before using computers my practice was to make many drawings and studies connected with a painting project, more as rehearsals than as 'working drawings'; I still make the drawings and the paintings, but my preferred medium for 'thinking

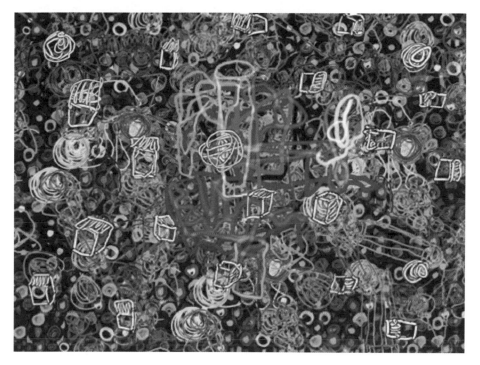

*Fig. 1. J. Faure Walker,* For the Bees, Night *2004 20″ × 27″ Epson archival inkjet print, June 2005.*

visually' is digital. One reason for this is that snapshot photography allows a painting to have the occasional glimpse of the textures of the 'real world' – a counterpoint to the eerie 'otherness' of geometric abstraction.

So the longer explanation of why a practitioner would wish to join the conversation is that sometimes the wrong history may be under discussion. The genetic make-up of today's digital artist is thought to consist of just one stream of art: the history of 'machine art' and the history of computers. The 'early' works that make up this supposed canon are the pioneer 'experimental' photographs of Muybridge; Duchamp's spinning discs; Constructivism; and algorithmic art. From here was the onward march, like the Chinese dynasties, where a succession of technological art formats annihilate their predecessors: Artificial Intelligence, interactive art, Net Art, wearable Information Art, consciousness-enhancing art. It is really a Woody Allen script: New Media! New Art! It is not that I do not respect those achievements or feel the force of the counterculture. It is that they have no *special* relevance or priority in the vast seas of art history. There are so many additional influences that would enter my own equation: from Pollock, de Kooning, Dubuffet, Rauschenberg, Warhol, Beuys, Richter, to younger painters such as Neo Rauch. I cannot speak for other painters using computers except to say that most are not isolationists, purists or dissidents shut off from 'the art world' – whatever that is. They feel connected with the wider history and with the dynamics of contemporary art. If they are frustrated it is because they feel trapped in the ghetto of trade show exhibitions, under a 'digital' art label, as if the only art they ever look at is digital art. In their hearts they feel they belong in the

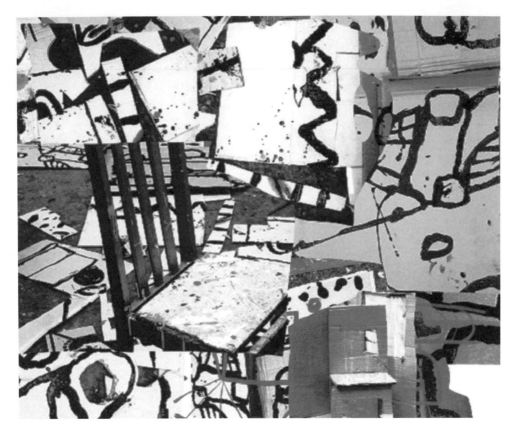

*Fig. 2. J. Faure Walker*, Studio Chairs *24" × 34" giclee iris print 2002.*

bigger picture. Some no longer show at digital shows or contexts where they will be identified primarily by medium. Using a computer was once such an all-absorbing task that it probably meant letting the *ArtForum* subscription lapse, but now there is no excuse for being uninformed. It is a tough message, but these days your work has to hit the spot as art, not as 'computer art'.

If the next generation of books on digital art do not have a Muybridge 'animal locomotion' reproduction in Chapter 1, what would they have instead? A facetious answer would be they might begin with medieval digital and go through to pointillism, showing that even though they lacked the mainframes, artists were thinking digital, seeing digital, and arranging the structure of paintings with colour and spatial awareness that was centuries later customised in Adobe Creative Suite. That, I confess, is my approach. As a reader, I find the history of computer graphics itself (especially the anecdotes of Alvy Ray Smith)[3] as interesting and certainly humane as the story of computer art. The trouble is that at every computer art conference I go to I tend to be as interested in the latest release of software, the new motion capture system, and the latest piece of interactive art. Then, after a few hours in the museum nearby, I come out wondering why my generation – myself included – is not producing works that can hold their own in that company. At the Frieze Art Fair I see the finesse, the lightness of touch, the confidence of a milieu

*Fig. 3. J. Faure Walker*, Pigeons, Kyoto *2002 giclee iris print 29" × 43"*.

aware of its cultural references, a place where painting and photography command most attention. In comparison, the world of digital art seems parochial, fixated on its own issues, speaking to itself, and preoccupied – some of it at least – with its family tree. Your work may be feeble, but leave it in a drawer for thirty years and, who knows, it could be Ph.D. source material!

The problem is not the lack of historical recognition so much as the lack of critical thought. Sometimes practitioners who use the model of an old medium – like painting – to get to grips with new technology are described patronisingly as lightweights, unable to come to terms with the real 'digital issues'. It is as if there is some agreed master plan that sets out the route a 'serious' artist must take once the laptop has been purchased. The 'Big Idea' is that digital art should be about 'digital things' – i.e. Artificial Intelligence, surveillance, the media, bio-feedback. Saying that digital art should concentrate on what cannot be done any other way sounds fine and hits the core. In comparison, using software to imitate paint is on a par with repro rococo. Speak about 'code' and you go deep. Speak about colour, pigment structures, compositional principles, decoration and you are messing in the froth.

I would prefer a more relaxed framework for interpreting what has taken place, not the tunnel vision of those who worship self-customised programming, much as Henry Tonks at the Slade a hundred years ago[4] saw anatomy and the use of X-ray as the key to painting. English painting, dare I say, had an appalling record for a long time, repeatedly inhibited by the fear and dogmatism cultivated in its art schools. Perhaps that is one history that deserves to stay buried. Some of us prefer to use 'high tech' to examine leaves, insect wings, what lurks in the pond, or to make frivolous patterns in the air. In the literature on 'new media' there is not much

*Fig. 4. J. Faure Walker*, F-G Restless Inventor of Cinema *2000 giclee iris print 20″ × 28″*.

*Fig. 5. J. Faure Walker*, Upper Street *2004 26″ × 35″ Epson archival inkjet print*.

*Fig. 6. J. Faure Walker*, Frog, Greenwood Road *61" × 68" oil on canvas.*

criticism that reflects on the fact that there was plenty of art around before there were any electronic systems. It was possible to make art without a computer then, and it is possible now.

## Notes

1   Ed. note: The Signals Gallery in London evolved from the Centre for Advanced Creative Study which was established in 1964 by David Medalla, Keeler, Guy Brett, Marcello Salvadori, and Gustav Metzger; *Cybernetic Serendipity*, An exhibition curated by Jasia Reichardt at the ICA London, 2 August to 20 October 1968.

2   Faure Walker, J. (2006), *Painting the Digital River, How an Artist Learned to Love the Computer*, Upper Saddle River, NJ: Prentice Hall.

3   Ed. note: Alvy Ray Smith's website is at www.alvyray.com (20 September 2005).

4   Ed. note: The English painter and draughtsman Henry Tonks (1862–1937) came to painting from a successful surgical career. From 1887 he studied at Westminster School of Art, finally abandoning medicine in 1893 to join the staff of the Slade School of Art in London, where he taught until 1930.

# Microanalysis as a Means to Mediate Digital Arts[1]

## Matthias Weiss

From a German perspective, academically oriented art history generally ignores the fact that the computer is, and has been, both a tool and a component of art for nearly as long as the machine itself has existed. A reappraisal of this history which attempts to place it in an art history context is therefore still needed. This perspective shifts when the international art scene and the many varieties of computer art that closely follow developments in the technological domain are considered. In this paper, two stimuli are examined as a means to look at computer art in an art historical context. The first attempts to define the topic and clarify the historicity of the phenomenon in stages, the second examines the role that description (i.e. especially microanalysis) plays in order to show that close examination facilitates differentiation and that comparisons between older and newer works are possible. Thus, the potential for a more profound understanding of computer art is created. In the first section, I examine connections that have been neglected to date, in the second, I discuss two works from two different periods that are effective illustrations of the history of computer art. The term 'computer art' is used in the accepted sense to refer to the use of digital methods in the production of artworks.

## Definitions

In order to be able to understand the phenomenon of computer art, a context is required. The term 'computer art' rather than 'software art' is used because the former implies a historically integrated factor that permits a comparative investigation of computer art. Using this approach, connections between the latest phenomena which have achieved great popularity in the field of New Media art and art works from the 1960s and 1970s will be established. By looking at the artistic use of computers from a historical perspective, these connections make it possible to assess their importance and role within art as a discipline. It is also important not to draw type distinctions categorically between immersive artificial worlds (or augmented reality projects), which are generated by using computers and 'software art' programs. In recent art history, this division has led to a less than fruitful connection between interactive environments and video art, which, as a supposedly logical consequence from the history of film, has prescribed the digital as the medium of the future. It is also necessary to draw a distinction between the different developments and impacts of video art as well as computer art, although intersections certainly exist.

I refer to computer art as a kind of artistic activity that would not be possible or have any meaning without computers. For example: a specific script that can run on any ordinary computer (and that actually requires it for the desired performance), or a

remotely connected installation which generates artificial life forms in a projection room using distant computers over the Internet with local user input data. Both are determined by the use of computer systems and a communication structure, and both would be unthinkable without these components. All of these technologies contribute to meaning.

## History

The history of computer art can be classified into three phases, defined by and dependent on what was technically feasible at the time. In the first phase, mainstream computer art fed back into aesthetics, which, in turn, developed into two models of non-representational art – abstraction and concretion. This phase ended in the mid-1970s. The output consisted of graphics along with works such as Videoplace by Myron Kreuger.

But this type of work could be considered as being part of the second phase. As computing capabilities increased and industry, from mechanical engineering to film, discovered simulation, immersive artificial worlds also began to be used for artistic experimentation. This trend was influential in prominent institutions such as the Center for Art and Media Technology in Karlsruhe and Ars Electronica in Linz, as well as the media arts scene. With the recognition that contemporary physics had called into question the role of philosophy as the primary field for the development of world-views, models like Chaos Theory began to be seen as inspirational for the art scene. This motivated artists interested in mathematics and cybernetics, like Karl Gerstner, to create the 'new image of the world' with fractals. At that time, technical arts became institutionalised at institutes of technology along the same lines as that established at the Center for Advanced Visual Studies (CAVS) at The Massachusetts Institute of Technology (MIT). But still the concentration on images, the constant insistence on the production of two-dimensional

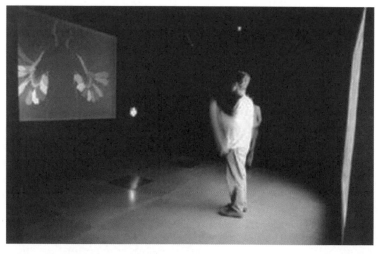

*Fig. 1. Myron Kreuger,* Videoplace. Videoplace *was a responsive environment which was operated by the computerised data of the public's movements.*

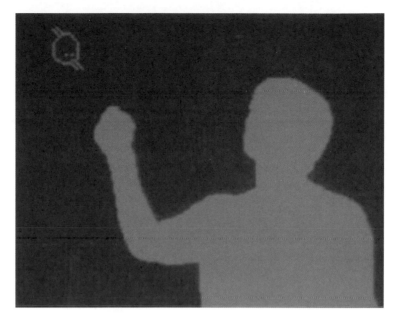

*Fig. 2. Myron Kreuger*, Videoplace.

visualisations, on one hand, and the extremely expensive development of three-dimensional image machines, like caves, on the other, caused a schism in computer art and led to the third phase.

While the computer artists of the 1960s were usually working under the paradigm of an art of precision and traditional imaging, they were rather insensitive to other current forms of art which were dedicated to communicative or politicising actions. Performance work could not be taken up by computer artists who were 'object-oriented'. For this reason, no direct influence from the artists and pioneers of the technically oriented arts of the earlier period is detectable on the contemporary computer art scene. It is not surprising that static computer graphics, which largely comprised the computer art of phases one and two, only became part of the system of art in an irregular manner, as for some time, art had been trying to change social practices through artistic action. In addition, given that the technology did not make possible what could already be achieved in the analogue world – with its mail, fax and copy machine networks – it is understandable that computer art made no lasting impression on the aesthetics of information. The following section discusses whether there are missing or hidden links and examines examples of the works.

## *Schotter* by George Nees

This work by Nees is a portrait-format graphic assembled from twelve sets of twenty-two squares, each set having the same length along the sides. Read from left to right, as one would read a European language, it shows disorder that increases from top to bottom as one views the graphic. The visible defines the order, which is not the same as the order of the pictures, but an optimal state in which the squares

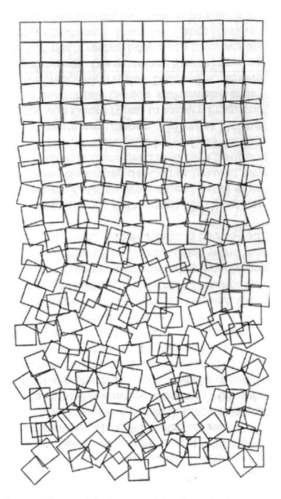

*Fig. 3. Georg Nees,* Schotter. *The graphical output of the piece of software programmed by the artist.*

lie along a horizontal line, forming a row in which each one is set precisely beside the next one, so that straight lines are formed by the upper and lower edges. This state is not seen in the picture as illustrated here. Row by row, the state of disorder successively increases down to the lower border of the picture. The program creates disorder through the rotation of each square at the point of intersection of its diagonal and, also, through the increasing distortion in the graphic space.

This graphic introduces a number of questions concerning the relationship between an image that is constructed and one that is computed. For this reason, the slight possibility of gaining insight through viewing has to be assessed by comparison with a work of 'classical' constructive art. In this way, by means of observation, the intent of the picture, or its inherent logic, can be recreated. This raises the question – what is the actual content of the picture? It could be argued that the picture illustrates the relationship between order and disorder. The rather orthogonal section of ordered squares in rows next to each other (up to row six) can

be evaluated as a state of higher ordering compared to the lower section of the image. We cannot tell by mere viewing, however, exactly which processes are responsible for the increase in disorder. The coordinates and inclinations of the squares could of course be measured, but this would result in defining a boundary that could not be crossed by inspection. It must be assumed therefore that the observer actually sees past the sense of the picture or extracts each of its senses visually without having them supported contextually. With additional viewings, a spatial effect becomes apparent, an optical illusion of a gentle turning from the inside out in the centre left and lower right of the image area. A graphical realisation of a mathematical model that was coded by means of a formal language constitutes its context. The question arises as to whether the image is above and beyond a specific visualisation randomly generated by a machine.

This raises another important question: is the depiction then a picture, a diagram, a technical drawing, or something in between? Successive examinations of the image from top to bottom gives the impression of increasing deviation from the system of order (as described above). However, upon further examination, structures appear even as disorder increases: structures that cross over from the formal context of individual pieces through their respective positions relative to each other on the surface to new non rigid geometrical figures. An interpretation allows us to claim that the condition of increasing disorder allows ordered structures within the image to appear, without clearly fixing them into definite geometrical forms. This effect can be described using information theory by stating that super-symbols are being formed in the region of disorder. It could be described as having dynamic and contingent qualities. The upper portion of the image, however, is static. This leads to the realisation that by interpreting the results of observation on a higher plane, dependent elements of order are visible within the realm of disorder. This does not occur in the region of the image with higher order. Here it is evident that an additive lining up of squares can, in turn, lead only to the formation of other squares or rectangles.

Examining the programming that actually gave rise to the image reveals that the optical evidence for simultaneous states of order (without the generation of formally divergent super-symbols) with a relatively gradual transition into disorder – a disorder that evokes contingent and formally divergent super-symbols – is a feature of the programming. As a result, the role of random generators that programmed chance in the parameters would have to be taken into consideration. Nees writes:

> Image 38, *Schotter*, is produced by invoking the SERIE procedure [...]. The non-parametric procedure QUAD serves to generate the elementary figure which is reproduced multiple times in the composition process controlled by SERIE. QUAD is located in lines 4 through 15 of the generator. This procedure draws squares with sides of constant length but at random locations and different angles. From lines 9 and 10, it can be seen that the position of a single square is influenced by random generator J1, and the angle placement by J2. The successively increasing variation between the relative coordinates P and Q, and the angle position PSI of a given square, is controlled by the counter index I, which is invoked by each call from QUAD (see line 14).

It can be concluded that the meaning of an image, which adds value to that which the work has as a diagram of a formula, can only be deduced if an integrated

```
1    'BEGIN''COMMENT'SCHOTTER.,
2    'REAL'R,PIHALB,PI4T.,
3    'INTEGER'I.,
4    'PROCEDURE'QUAD.,  # generates the main figure, a square
5    'BEGIN'
6    'REALP1,Q1PSI.,'INTEGER'S.,
7    JE1.=5*I/264.,JA1.=-JE1.,  # random generator 1
8    JE2.=PI4T*(1+I/264).,  # random generator 2
9    JA2.=PI4T*(1-I/264).,
10   P1.=P+5+J1.,Q1.=Q+5+J1.,  # changing the coordinates
11   PSI.=J2.,
12   LEER(P1+R*COS(PSI),
13   Q1+R*SIN(PSI)).,
14   'FOR'S.=1'STEP'1'UNTIL'4'DO'
15   'BEGIN'PSI.=PSI+PIHALB.,
16   LINE(P1+R*COS(PSI),Q1+R*SIN(PSI))
17   'END'.,I.=I+1
18   'END'QUAD.,
19   R.=5*1.4142.,
20   PIHALB.=3.14159*.5.,PI4T.=PIHALB*.5.,
21   I.=0.,
22   SERIE(10.0,10.0,22,12,QUAD)  # multiply the main figure
23   'END'SCHOTTER.,
```

Nees, Georg: Generative Computergraphik. 1969, p. 241

*Fig. 4. This code generates* Schotter.

investigative model is applied, comprising both observations and investigation of the computational foundations.

In a logically deterministic computer program, this action then imposes a relationship between an experience in observation and knowledge about the abstraction of a problem. It can be seen that, on the one hand, understanding is determined exclusively from a unilateral investigation of the source code and, on the other, from the examination of the image alone. This is because in contrast to a composition created in the traditional way – by the visual calculations of an artist in a series of trials, or simply through the creation of an image – however it came about, an examination of the source code shows that in *Schotter*, it exists in the form of one of the n-possible graphical states of the program. In terms of computer art, this is the key element of this work. At no point is there an integration of the code and the visual, and this is typical of early computer art because other arts – for example, concept art and performance art – had yet to be appreciated.

## *Forkbomb* by Alex McLean

*Forkbomb* (http://runme.org/project/+forkbomb/, 2 November 2005), which Alex McLean wrote in 2001 using the PERL scripting language, is essentially a thirteen-line program that found its way into the art community through *transmediale.02*, where it won a prize. In describing the function and action of the script, a certain radical quality is apparent, coupled with the claim that this piece of software is art. It is, in fact, nothing other than an uncontrolled system halt. Through mechanisms that will be described here, the code gradually paralyses the system on which the interpreter applies the script. This occurs through a so-called 'process' that branches out and launches an avalanche of identical processes. This continues until – depending upon the capabilities of the computer – the system resources are exhausted and a system halt results. At that point, an output is produced as a bit pattern of zeros and ones. On the homepage of *transmedial*, the following message appears: 'The pattern in which these data are presented can be said, in one sense, to represent the algorithm of the code, and, in another way, to represent the operating system in which the code is running. The result is an artistic expression of a system under stress.'

In the first-line pathname, the symbols '#!', which can be called 'hash-bang' or 'shebang', instruct the shell through which UNIX systems are accessed to use PERL for executing the code. These lines of code are not executed by the interpreter (in this case PERL) but only instruct the operating system that the text and data in which the code itself resides is designated for the PERL interpreter. The characters that follow define the standard path to PERL. The '-w' at the end instructs the interpreter to produce error messages. As a rule, this is used when newly written programs are being tested. The command 'strict' at the end tells the interpreter to generate error messages whenever the code is improperly written. The script itself is not something that can be started up with a double click on a symbol like a text processor, as is generally the case for an icon paradigm with a graphical user interface. It is started via a command line where an integer value is input. This is then transferred to the program as the 'strength' of the 'bomb'. This specific value has to be entered. Otherwise, the following message appears: 'Please do not run this script without reading the documentation' and the program breaks off.

The 'die' subroutine causes the system to carry this out. If the value of the argument, which is given on the command line and passed through the so-called special array '@ARGV' is already zero, the program ends without generating messages. If a value

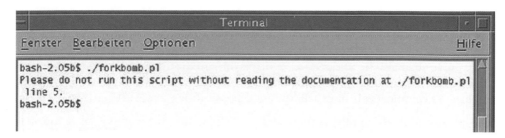

*Fig. 5.* Forkbomb *by Alex McLean.*

in the form of a positive or negative integer is specified on the command line, the error messages are passed over, and the code which follows afterwards is executed. In the fourth line, the variable 'strength' is declared and defined. It has to be modified by 'my' because the 'strict' instruction forces the programmer to observe a rigid syntax. In this way, the system can immediately identify improper declarations. The value of 'strength', which corresponds to the special variable ($ARGV), is determined from the input value on the command line. After this, the value that the user has chosen is increased by 1 (line 4). Up to this point, the program has either broken off, after inviting the user to read the documentation, or has increased the strength of the bomb by 1. What follows is the part where the fork process is initiated. The 'while' statement initiates a loop if the condition in the adjoining parenthesis (not fork) is not true. Despite this, the fork instruction triggers the first fork process. If the system determines that 'not fork = true', then the program goes to the first loop. The program stops here ('exit', line 6), if the variable 'strength' has already become 0 (lines 9, 10) through a 'decrement' process (indicated by '–'). In this case, a 0 is sent to the standard output (line 7) and the execution of the program continues from line 8.

Back in line 5, if the system determines that 'not fork' is false, the program jumps to line 13 ('goto [...]'). At this point, the program is instructed to jump back to line 8. Another 'fork' is started here. If the system comes back with 'false', the program again jumps back to line 13. If, during the process of 'decrementing' (which is indicated by '–'), the variable 'strength' is already 0 (lines 9, 10) and if the statement is 'true', the program stops again. Otherwise, the program produces the number 1 as an output and continues on in line 13. The string continues to be executed until every process by means of decrementing goes to zero. This only occurs, however, if a positive value was input on the command line. If a negative value was entered, the program does not end. This is also the case for the program run if the first loop has ended and 'strength' (line 6) is still not exactly 0.

Along with the relationships of the conditions described in the program, and with the increasingly random dynamics that are produced by an output of 0 or 1, these processes are carried out identically in each offspring process. In general, this means that the script initialises a cascade of loops which, although they follow a programmed logic, use the inherent logic of the system itself in a way that it was not intended to be used. When the program is started, a succession of zeros and/or ones can be seen on the standard output device, which nowadays is usually a monitor screen. From this, the part that the 'while' statement has already executed can be recognised. The computer gradually becomes paralysed and, as this happens, the output changes.

The software can also be interpreted as being a random generator. However, this does not fulfil the function that it had in the work of Nees, for example. In any case, the program can also be understood as displaying the finite nature of the computer – in contrast to the attributes ascribed to it by industry, which has elevated the machine to mythic levels of capabilities and possibilities in advertisements.

The program is efficiently written and so fulfils the requirement of a 'normal' computer program. In the way it works, however, it overturns the paradigm of

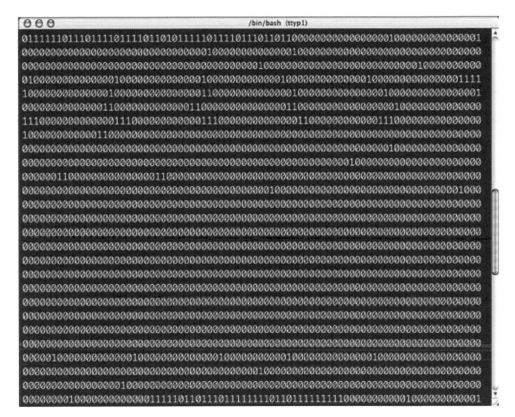

*Fig. 6.* Forkbomb *by Alex McLean.*

functioning. If an attempt were made to use the program in a productive context, there would be no more productivity because, most likely, the system would have to be restarted again and again. In this respect, it is something other than that which, by means of norms and other controls, is brought under control and classified as art and, at least in theory, remains controllable. In the digital day-to-day world, it is tempting to compare this to a virus. By placing the section of code in an artistic context, another arrangement for both the code and its developer is appropriate. As a rule, if the legal system steps in quickly to arrange the safeguarding of normality, lawsuits will be brought against programmers who do not follow the dominant paradigms of the respective programming languages, but rather use these languages intentionally for destructive purposes. If the functionality is described metaphorically as a virus, and is interpreted as such, then there is room for discussion. For this, only a limited analysis of the code, such as is undertaken above is needed. But here the work falls apart into code/effects and the context noted above, without any conclusions being drawn concerning possibly significant formalisms or conventional subjects. On the positive side, this would, however, contradict the definition of computer code which, being clear and unambiguous, excludes any semantic relationship in its elements. In a way, every higher language possesses the possibility of semantically charging symbols with variables which are named arbitrarily.

McLean calls the core variable of the program 'strength'. As described earlier, a 'my' has to stand in front of this variable since all variables must be declared accurately. This produces the phrase 'my strength'. If a lyrical 'I' were put into the text, then some interpretation would be needed to provide meaning. The instruction 'twist' could also be viewed similarly, a word that, in the context of programming, could be chosen arbitrarily and which forms the anchor point for the 'goto' instruction. It does, however, seem that the relationship of three semantically charged symbols, relative to the formal arrangement of the code, is rather arbitrary. The probability that there is then a subtext behind what is explicitly stated is small.

## Conclusion

Although it is widely understood that computer art has a position in the art world, its role in relation to contemporary art is not quite clear. From a modernist perspective, the two works described above lack a relationship between the code and its effect. It is easy simply to use zeros and ones to represent the raw material of a calculating machine such as *Forkbomb*, but this raises questions about the role and necessity of such a device. In the author's opinion this is a weak example of the representation of computing technique metaphorically. The two examples discussed also appear to disregard what could be considered intrinsic elements of the visual arts, such as an awareness of the references of all parts of an artwork and their logical relationship with each other, as well as the historical context.

This conclusion could not be drawn without understanding the code of both pieces, and, therefore, the author considers it advisable that art historians working with computer arts develop some understanding of the technical elements of such works.

## Note

1   This text appears under the Creative Commons Licence 'Attribution NonCommercial-NoDerivs 2.0 Germany', http://creativecommons.org/licenses/by-nc-nd/2.0/de/ (2 November 2005).

## Further Reading

Alsleben, K. (1962), *Aesthetische Redundanz*, Quickborn: Verlag Schnelle.

*Aus 1 mach 2: Forking,* http://www.cis.uni-muenchen.de/~hbosk/programmentwicklung/forking.html (active 2 February 2006).

Bense, Max (1969), *Einführung in die informationstheoretische Ästhetik. Grundlegung und Anwendung in der Texttheorie*, Reinbek: Rowohlt Verlag.

Broeckmann, A. and Jaschko, S. (2001), *DIY Media – Kunst und digitale Medien: Software, Partizipation, Distribution,* Berlin: Dokumentation transmediale.01 (international media art festival).

Daniels, D. (2003), *Vom Readymade zum Cyberspace. Kunst/Medien Interferenzen*, Ostfildern-Ruit: Hatje Cantz.

Dinkla, S. (1997), *Pioniere interaktiver Kunst von 1970 bis heute*, Ostfildern: Hatje Cantz.

Franke, H. W. (1971), *Computergraphik – Computerkunst*, Munich: Bruckmann.

Hoffmann, J. (1995), Destruktionskunst. Der Mythos der Zerstörung in der Kunst der frühen sechziger Jahre, Munich: Verlag Silke Schreiber.

Jäger, G. (1973), *Apparative Kunst. Vom Kaleidoskop zum Computer*, Cologne: DuMont.

Moles, A. A. (1973), *Kunst und Computer*, Cologne: DuMont.

Nees, G. (1969), *Generative Computergraphik*, Berlin/Munich: Siemens AG.

Piehler, H. (2003), *Die Anfänge der Computerkunst*, Frankfurt/M: dot Verlag.

Spainhour, S. (1999), *Perl in a Nutshell*, Sebastopol: O'Reilly.

Steller, E. (1992), *Computer und Kunst. Programmierte Gestaltung. Wurzeln und Tendenzen neuer Ästhetiken*, Mannheim, Leipzig, Vienna, Zurich: BI Wissenschaftsverlag.

# Indexed Lights

## Pierre R. Auboiron

*The proper artistic response to digital technology is to embrace it as a new window on everything that's eternally human, and to use it with passion, wisdom, fearlessness and joy.*

Ralph Lombreglia

One of the most vivid modern metaphors for light is its allegoric embodiment of electricity. Although invisible, electricity is often represented by brightly coloured sparks and flashes. In the collective consciousness light is the true substance of electricity. Therefore, it is not surprising that a light is found on most electrical appliances indicating that they are in working order, or, to put it differently, whether the electrical current is active. On a computer, small flickering lights indicate an active hard drive or network connection. These lights are vital sensors indicating that our ever more humanised computers are working.[1] Many people are familiar with the image of HAL, the computer which played a leading role in Stanley Kubrick's film *2001, A Space Odyssey*. HAL's physical presence was manifested by a visual sensor: a simple lens lit by an inner reddish glow. It is worth noting that Arthur C. Clark describes HAL as a simple 'spherical lens' in his epic. The red glow was Kubrick's addition; it allowed him to animate HAL with an inner fire[2] giving HAL a disconcertingly human feel. This is directly linked with both metaphorical and metaphysical aspects of light: since the origin of humankind, light has represented and embodied what is invisible and intangible as well as what has disappeared.

Visual culture is *here and now* and its hegemony within our cities no longer needs to be proved. Light, being the essence of any visual communication, and new technologies, as prevailing information vectors, have both played a leading role in the hegemonic expansion of visuality in the City. The proliferation of neon signs, plasma screens, and lighted shop windows are all symptomatic. The history of urbanism tells us that the City has always been the birthplace of every paroxysm: technological, social, cultural, artistic and economic. From this perspective, the City has, naturally, become the temple where all forms of visual media are not just celebrated but even over-consumed. It is the place where all aspects of human activity are concentrated, emphasised and crystallised. Cities have become the privileged scene of this complete and radical transformation of the rhythm of human society. A new architectural approach to light has become widespread: In the course of the last few years the novelty of new architecture lies more in the way that it is illuminated than in its outer design.

Architects and town planners have always obsessively sought to master light, but it has proved ever-elusive. The discovery of electricity and its large-scale generation provided the first true opportunity to push back the night. From this perspective, light, which was initially used to make our streets safer, has swiftly become a powerful tool which rationalises and signposts the City at nightfall. At night, a city is

first announced from the distance to an approaching traveller by its diffused lights in the sky. However, owing to the development and democratisation of new technologies, urban lighting schemes have entered a new age and, accompanying this, an alternative and oneiric approach to light has emerged. This has lead to a significant break with the traditional comprehension of light in the City.

Two artists in particular have embraced this new approach to urban lighting: the French light designer Yann Kersalé and the Japanese architect Toyo Ito in collaboration with the engineer Kaoru Mende. While it is sometimes difficult to say whether Japanese culture today is more western than Oriental, Kersalé and Ito have both shown how questionable it would be to limit the study of current urban lighting to western culture alone as it is a truly pan-cultural phenomenon. Using very complex lighting systems, made of captors and computers, these artists can materialise and visualise environmental phenomena such as noises, draughts, the current of a river and invisible human activity on the buildings themselves. Thereby they intend to make buildings fit back into their historical and socio-geographical environment.

## A Societal Indexation of Building Lighting

Yann Kersalé is a French visual artist born in 1955. He has worked with light for over twenty years and has collaborated consistently with the French architect Jean Nouvel. Kersalé uses light as a societal tracer, which can recreate the historical and socio-geographical surrounds of a building. Using Mirzoeff's words, we can say that Yann Kersalé's light installations 'seek out an intersection between visibility and social power'. This is particularly evident in the piece entitled *La ville-fleuve (The River-City)*.

In 1992, the city of Nantes entrusted Yann Kersalé with the lighting of its cathedral. In this project, the artist broke the tacit rule for lighting a Gothic cathedral, which suggests that light should only outline the building's verticality. At night, the massive cathedral of Nantes is totally disintegrated by 1,900 blue spotlights. Their blue hue varies constantly according to data recorded by capturing devices set in the bed of the river Loire. The effect of this variation evokes Monet's series of paintings of Rouen Cathedral, being closer to the idea of visual impression than to the idea of representation. The nocturnal aspect of the building evolves from day to day depending on the strength of both the river's current and the ocean's tide.

Kersalé's intention was to put the cathedral back into its historical socio-geographical context. To describe his concept, Kersalé uses the term 'geo-poetics'.[3] Indeed, the city of Nantes originally flourished thanks to its location by the estuary of the river Loire. The river could be considered as the main artery of the medieval city with the cathedral as its heart.

A year later Kersalé worked in Lyon on another project entitled *Le théâtre-temps (The Time-Theatre)*. He was asked to set up a new lighting system on the roof of Lyon's Opera House which had recently been renovated by the French architect Jean Nouvel. The red lighting of the roof changes depending on the level of human activity inside the building. This activity is constantly recorded by capturing devices and video cameras throughout the building. In this project the lighting puts the

emphasis not only on a piece of architecture combining Neoclassical and modern styles, but also on the societal functions of the Opera House which is at the heart of one of the main districts of the city. Kersalé helps us understand that a building has its own life form[4] and story to tell. His varying lighting tells us that the Opera House is constantly full of activity, even outside opening hours. Thus, a diffused, pulsing glow betrays overnight rehearsals.

The same desire to make a building fit its societal environment governed the building of Toyo Ito's Tower of Winds in Yokohama in 1986. This tower was made as a ventilation and water tank facility for a mall situated immediately beneath it. A series of perforated aluminium panels form an oval cylinder all around the concrete structure. A very complex lighting system, also based on the use of capturing devices, allows the materialisation and visualisation of 'natural' phenomena such as ambient noise and the movement of wind around the tower. The outer structure of the tower can look either like a brightly floodlit envelope or like a translucent film animated by colourful waves. A critic described the tower as an 'audio-visual seismograph' displaying a variation in lighting 'ranging from glowing sparks to flashing strobe light, from geometrically regular intervals to amorphous shifts and flows, from retarded slow-motion to stroboscopic excitement, with all kinds of transformations and variants in between.'[5]

Ito's work is based on a stratified perception of urbanism which can be roughly summed up as a two-layered system: the layer of the urban fabric comprising buildings, roads, rivers, etc. and the phenomenological layer comprising human influx, draughts, thoughts and data flows. According to Toyo Ito, 'this project is a conversion of the invisible rhythm and colour (made tangible through light, sound, air, etc.) of the city of which bodies are subconsciously aware due to a variable pattern of light.'[6] Due to a lack of funds and maintenance, The Tower of Winds has not, or has only partially, been illuminated in recent years.

This type of project is not exclusively Japanese or French. When Jonathan Speirs was asked in 1996 to design the lighting of the technical tower of Bridgewater Hall in Manchester, he decided to turn it into a Tower of Time. There are three different light indexations: the interior lighting changes according to the Zodiac cycle, while light 'on the exterior reflects the time of year, starting with green for spring, and running through yellow, red and blue, denoting each subsequent season in a gradual wash of colour'.[7] Last but not least, lines of light tubing delineate the eight storeys of the building and indicate the day of the week. This complex abstract clock obviously echoes ancient observatories like Stonehenge and the ancient desire to adjust human activity to natural cycles.

In 1997, James Turrell was commissioned to light the office building and computer centre for the natural gas industry, the Verbundnetz AG in Leipzig. The building is totally self-sufficient in terms of energy due to both its own gas-fuelled power station and to a system adjusting the heating and air-circulating systems. The artist decided to index his lighting to this autarchic technological world. The light colours vary according to the temperature that the energy supplier provides. According to Turrell, 'Light should be a material with which we build'.[8] This suggestion echoes among light designers throughout the last third of the twentieth century.

## New Technologies and Urban Oneirism

All the artists mentioned above have based their work on a novel social or environmental indexation of light. Thanks to the sensitive application of new technologies, they make concepts and aspects of our everyday life visible and more tangible. Thereby, they try to fight the decline in interpersonal communication in today's urban life which is one of the results of increasing visuality. In this instance, computers, associated with light, act like prostheses and compensate for our inability to comprehend our environment in its entire complexity. They materialise phenomena we can no longer perceive because we have developed our visual sense to the detriment of our other senses. Here the artist's work does not deal with creating something new but with making existing things visible. Ito, Turrell, or Kersalé do not claim to produce an aesthetic experience in their work. They do not use light for its ability to mesmerise, but for its ability to embody the intangible. In some ways, this can be compared to the use of tracers in biology which reveal invisible processes or organisms.[9] Thus, they teach us how to look again at our direct environment by looking beyond the static aesthetic veneer[10] which now covers and conceals all aspects of society. After his collaboration with Ito on the *Tower of Winds*, Kaoru Mende commented that 'we are getting fewer opportunities to enjoy the sense of changing time. Part of the reason is that we have become accustomed to lighting environments which always stay the same.'[11] Thanks to this visual experience, people are becoming visually aware of the complex and highly interwoven societal system in which we live. This concurs with the desire of contemporary architects to incorporate light as a material in its own right as well as providing nocturnal visibility, when designing public buildings. From this perspective, they offer a more organic and intimate perception of their buildings by depriving them of any precise outlines and invading them with light. Thus, Toyo Ito explains that 'the Tower (of winds) with such physical presence loses its presence after sunset and metamorphoses into a phenomenon of light. I refer to this metamorphosis from an opaque substance into a transparent object of light as "fictional"'.[12]

'Fictional' may be a key word to help comprehend this very highly aesthetised[13] society in which we are living. Sight remains our last means to comprehend a world where we live immersed in a global visual cacophony from which it has become very difficult to isolate any particular message. Wind, air, feelings and ideas may be seen as fictional because they are not visible; in other words, all that cannot be seen is barely considered anymore. Human visual sense has hypertrophied in the course of the last century and tends to supplant other senses.

This societal phenomenon cannot only be explained as an overdeveloped societal narcissism. Western societies are now revolving around the hypothetical concept of a single, standardised, fictional self. It heralds the end of any form of social cohesion and with this in mind specialists in the Humanities, such as Susan Buck-Morss, now agree that autism appears to be a societal interpretative model much more relevant than narcissism. New technologies have played a leading role in producing and maintaining this societal autism by disconnecting people from their real environment in favour of a so-called virtual society. Paradoxically, this paper shows that computers can also help people rediscover and comprehend their direct environment when hijacked by visual artists and designers. Their creations do not deal with any

fantasised vision of the society rooted in science fiction, but with a direct confrontation of everyday reality.[14] This could be summarised by Wyndham Lewis: 'The artist is always engaged in writing a detailed history of the future because he is the only person aware of the nature of the present.' This shows that, with the benefit of hindsight, computers can help us live in the here and now instead of throwing us into a frantic individual rush to the future.

We may now moderate the widespread notion that computers are synonymous with a cold and sanitised individuality. For instance, when Yann Kersalé or Toyo Ito tell the story of a particular building or district, they force the viewer to gaze afresh at the world. The current association of light and new technologies in large Light Festivals represents a new step in today's reappropriation of our urban and technological environments. The City has become much more than a simple artistic subject, it is now a large-scale location for societal experimentation. It seems that the last gaps in dreams must be sought in the eye of the visual whirlwind itself, in other words, in the City itself.

## Notes

1  We have all at some time anxiously stared at our computer lights waiting for them to flicker while hoping that hours of work had not been lost.

2  In some ways, both the metaphors of life and electricity can be superimposed: the electric current goes through an appliance as life flows through the human body.

3  Here Kersalé obviously plays on both the meaning and the etymology of the word 'poetics' which comes from the Ancient Greek 'to make'.

4  Light is unconsciously but deeply linked to the idea of life.

5  Neumann, D. (2002), *Architecture of the Night, the Illuminated Building*, Berlin, Prestel Verlag, p. 204.

6  Berwick, C. (1998), 'The Tower of Winds and the Architecture of Sound, an interview with Toyo Ito', *The Take Magazine*. http://www.thetake.com/take05/take04/html/42ndst.html (active 7 November 2005).

7  Neumann, D. (2002), *Architecture of the Night, the Illuminated Building*, Berlin, Prestel Verlag, p. 214.

8  Cooley, R. (2001), 'Interview with James Turrell: Adventures in Perception', *Architectural Lighting*, March.

9  Here we must think of one of the most popularised scientific images, the electrophoresis of DNA under ultraviolet lighting. This very strong image is linked with the decoding of life. It is no accident that memory sticks or USB ports are increasingly lit with hues evoking ultraviolet rays.

10  This means Aesthetics should not be considered as an ideal any more. Aesthetics is now something between a societal standard and a self-inflicted torture. Nowadays, any object, from the most insignificant to the most astonishing, is always perfectly but impersonally designed.

11  Mende, K. (2000), 'Trends in Urban lighting in Japan', *Philips Lamps and Gear Magazine*, 4:1.

12  Berwick, C. (1998), 'The Tower of Winds and the Architecture of Sound, an interview with Toyo Ito', *The Take Magazine*. http://www.thetake.com/take05/take04/html/42ndst.html (active 7 November 2005).

13  C.f. Michaud, Y. (2003), *L'art à l'état gazeux. Essai sur le triomphe de l'esthétique*, Coll. Les Essais, Paris: Stock.

14  Part of the strength of *2001, A Space Odyssey* lies in the fact that Kubrick contented himself with representing HAL by a simple glowing lens. This gives it a stronger presence than any type of anthropomorphic robot and evokes the red lamp which marks the presence of God in a church.

## Select Bibliography

Bouchier, M. (ed.) (2002), *Lumière*, Art(s) des Lieux series, Brussels: Ousia.

Cooley, R. (2001), 'Interview with James Turrell: Adventures in Perception', *Architectural Lighting*, March.

Kersalé, Y. (1995), *Lumière Matière*, Gallery Ma, Book 11, Japan.

Kersalé, Y. (2004), 'Géopoétique de l'espace', *Penser la ville par l'art contemporain*, Masboungi, A. (ed.), Projet urbain series, Paris: Éd. de la Villette, pp. 71–75. cf. the following papers in particular:

Makiarus, M. (ed.) (2000), *De la lumière. Revue d'esthétique*, 12, Paris: Ed. Jean-Michel Place.

Masboungi A. (ed.), (2003), *Penser la ville par la lumière*, Projet urbain series, Paris: Éd. de la Villette, *cf. the following papers in particular:*

Combarel, E., 'Et la nuit recrée la ville', pp. 104–106.

Fachard, L., 'Scénographie au service de la ville' pp. 54–62.

Fiori, S., 'Rencontre avec le public du festival des lumières', p. 89.

Gandelsonas, M., 'Logique des signes – la nuit américaine', pp. 100–103.

Kersalé, Y., 'Art-ménagement du territoire', pp. 64–69.

Narboni R., 'Brève histoire de l'urbanisme lumière', pp. 17–23.

Neumann, D. (2002), *Architecture of the Night, the Illuminated Building*, Berlin: Prestel Verlag.

Valère, V. (2000), *De la lumière*, Technè, 12, Paris, Centre de recherche et restauration des musées de France, CNRS-UMR 171, pp. 34–49.

# A Computer in the Art Room

Catherine Mason

The concept of using computers in art started in a sympathetic social and political climate in the UK. Although in the initial post-World War II period there were no computers available to artists, there was a wealth of conceptual thinking, informed by cybernetics, which influenced the next generation. With advances in technology and the formation of the polytechnics in the late 1960s, computers gradually became available to students. In certain institutions, a limited number of artists took up computing as a tool, working method or metaphor for practice. The complexity and rarity of computers at the time meant that any art form based around them was bound to be a specialised branch of art, highly dependent upon support and funding to exist, not least because of the expensive, large-scale nature of much early equipment and the technical expertise required to operate it. Due to these unique issues of access, both artists and technical or scientific professionals created work during this pioneering period.

This paper is a brief introduction to the role played by a number of British art schools in fostering computer arts activity during the period of 1960 to 1980. Far from being an isolated historical phenomenon, this activity, which largely took place in provincial art institutions, informed the development of modern art and design pedagogy whilst at the same time continuing a tradition of technical and artistic cooperation established in the nineteenth century.

Founded in 1837, the Government School of Design was the first state-supported art school in England and ancestor of the Royal College of Art and the Victoria and Albert Museum. Together with the provincial branches that were subsequently established, these schools were created to teach design skills using the latest tools in order to halt the decline of industrial art and compete with Europe. They taught both art (based on the 'high' art of figure drawing) and design (using the latest technology) in one place.[1] This construction of the modern world – the reform of society through the reform of design, notions of education through display and the belief in the power of technology to positively influence these – represents a particularly British engagement with the disciplines of humanities and science, stemming from the Industrial Revolution.

The influence of 'basic design', a new type of art education influenced by Bauhaus concepts, can be traced through art schools from the 1950s, when artists were informed by cybernetics, through the 1960s when artists were working in programmatic ways, and the 1970s when artists actually used computers.

Throughout the 1950s and early 1960s, computers were in the early stages of their development and were commonly thought of as 'number crunchers' or referred to as 'electric brains'. Not only was it difficult to access this equipment, but at this stage it was difficult to perceive the computer as an art method or material, let alone one with capacity for interactivity. The new scientific development of cybernetics, reinvented

in the twentieth century by the Massachusetts Institute of Technology mathematician Norbert Wiener, was to inform the gestation of computer arts in Britain. Cybernetics, the study of how machine, social, and biological systems behave, offered a means of constructing a framework for art production which allowed artists to consider new technologies and their impact on life.

The young members of the so-called Independent Group who gathered around the Institute of Contemporary Arts became interested in the implications of science, new technology and mass media for art and society. These visual artists, theorists and critics were inspired by *Scientific American*, Wiener's writings, Claude Shannon's Information Theory, von Neumann's Game Theory and D. W. Thompson's book *On Growth and Form* of 1917. They met officially between 1952 and 1955 and informed the next generation's interest, not least through their influence on advanced art educational developments in the 1960s.[2]

Richard Hamilton, Rayner Banham and other members of the Independent Group were involved with the exhibition *This is Tomorrow* at the Whitechapel Art Gallery in 1956. From the catalogue it can be seen that these artists had a belief in the power of modern technologies, even emergent ones such as 'punched tape/cards [...] operated or produced by motor and input instructions', for which the exact artistic employment cannot yet have been fully clear.[3] This ranks as one of the first published allusions to 'the computer' in relation to artistic practice in Britain.

In 1953, Hamilton went to teach under Lawrence Gowing, Professor of Fine Art at King's College, Durham University. Together with Victor Pasmore, Hamilton set up and ran the Basic Design Course, building; on the Bauhaus concept of an integrated method of teaching by bridging the gap between the disciplines of the life room and the rigours of basic design.[4] This was a unique approach at the time – no more copying from plaster casts, which had dominated art education since the founding of the Royal Academy!

Roy Ascott, a student of Hamilton and Pasmore, was encouraged by the process-driven way of working and taught on the Basic Design Course. Influenced by the radar technology encountered during his national service in the RAF and inspired by Pasmore's constructivism, Ascott incorporated an interactive element into his work that reflected his interest in communications. In 1961 he created a revolutionary course at Ealing Art School informed by the principles of cybernetics, which he named the Ground Course – a term which emphasised 'learning from the ground up'.[5] These courses were the result of the radical reform of education in the art and design sector put forward in the First Report of the National Advisory Council on Art Education (1960), under Sir William Coldstream. They replaced the outdated National Diploma in Design, paving the way toward the introduction of degree-level (BA) fine art courses.[6]

Other artists teaching at Ealing included Harold and Bernard Cohen, Adrian Berg, Noel Forster, Ron Kitaj and others. Ascott's method of teaching art was not based on the traditional 'master and apprentice' system. Instead, the course was based on behaviour and process, stressing media dexterity, interdependence, co-operation and adaptability. The tutors set the students projects using analogue devices such as calibrators for selecting human characteristics and behavioural alterations in a random

but systematic manner. Ascott brought in a number of important artists and theorists to give lectures and demonstrations, including the artist Gustav Metzger and the English cybernetician Gordon Pask.

In the early 1960s, in his manifestos, demonstrations and lectures, Metzger declared his interest in computer-controlled cybernetic systems and how computers could be used in sculptures to be auto-destructive. He was involved with the *Destruction in Art* symposium in 1966 and performed his famous acid piece on the South Bank Centre.[7] His position countered those who advocated the Utopian possibilities of the coming computer age, with sobering details of its origins in military research.

Among the first cohort on the Ground Course was Stephen Willats. Before reaching Ealing, Willats had already been exposed to avant-garde art practices through his work as an assistant, first, at the Drian Gallery, and, then, at Denis Bowen's New Vision Centre Gallery. He became interested in the audience's interaction with the art object and how the gallery might function in society. This early work (fig. 1), bears out Ascott's stated assertion that 'The studies of communications, including the making of charts and diagrams [...] are an integral part of the Ground Course.'[8]

When Ascott became Head of Fine Art at Ipswich Civic College (1964 to 1967), Willats joined him on the teaching staff. Here, Willats continued his interest in using informed and up-to-date technological models to produce interactive collective

*Fig. 1. Stephen Willats,* Conceptual Still Life, *1962. British Museum, London.*



projects with students. These ideas were further developed at the Department of Fine Art at Trent Polytechnic, Nottingham where Willats moved in 1969.[9] A collaborative work from this period, *Man From The Twenty First Century*, was an 'attempt to extend not only the concerns of art practice but also the social territory in which it functioned'.[10] The idea was to build a meta language between two geographically, economically and socially separated communities, actively involving non-traditional art audiences.[11]

Stroud Cornock, a Royal College of Art trained sculptor, also worked with Ascott at Ipswich during the mid-60s, later moving to the City of Leicester Polytechnic where he founded Media Handling in 1968. One of the main principles of this course was the belief that any medium had validity for artistic activity.[12] In 1971, *The Invention of Problems II* event and exhibition were held at Leicester. Speakers at the symposium, *Creativity in a Machine Environment*, included artists, academics, an architect, scientists and engineers drawn from around the country – the cybernetic sculptor Edward Ihnatowicz, Willats, Ernest Edmonds, George Mallen, Cornock himself and others. The Dean of the polytechnic acknowledged the increasing importance of the cross-disciplinary aspect possible in such institutions stating, '…not only do we wish to see our artists share in the skills of their technical colleagues, and vice-versa, but we also seek some overall purpose in these activities through the joint application of such creative collaboration…'[13] It is entirely appropriate that Leicester became the first institution in the UK to award the Ph.D. in Fine Art in 1978 to Andrew Stonyer, an artist working in solar kinetics – what today would be termed New Media. Stonyer's supervisors were the Head of Sculpture and a Reader in Chemistry, with the Slade School of Art as the collaborating establishment.[14] Arguably such an accomplishment would not have been possible outside a polytechnic, which was pioneering in its collaborative research-based culture.

*The Invention of Problems II* event primed Cornock's student Stephen Scrivener, who was at the time working on kinetic and light pieces, for the idea of using the computer in art. Scrivener went on to be among the first cohort at the newly set up Department of Experiment (later known as the Department of Experimental and Electronic Art) at the Slade in 1972.[15]

Concurrent with these educational developments was the 1968 exhibition *Cybernetic Serendipity*, curated by Jasia Reichardt and opened at the Institute of Contemporary Arts in London by Tony Benn (who, at the time, was Minister of Technology).[16] It represented a culmination of the great interest in cybernetics and art in Britain during the 1960s, and it is still considered to be the benchmark 'computer art' exhibition.

One of the main characteristics of British computer art in the 1970s was that it involved artists who either learned to program and write code themselves or built up a working relationship with scientists, engineers or technicians, at a time when the computer itself was at a formative stage. This was made possible largely by the creation of polytechnics, which concentrated expensive resources into fewer, but larger, multi-disciplinary centres. The first were designated in 1967 and many art schools were amalgamated into them.[17] In a few institutions at least, the result was that artists had the opportunity to access expensive and specialist computer equipment and technical

expertise (generally belonging to the science or mathematics departments) for the first time. These provided not only education and training but in some cases career incubation, employment, research facilities and networking opportunities. This was a unique feature of British education at this time – as an art student, one could learn computer programming. Thus, like the first public art schools of the nineteenth century, the polytechnic offered the opportunity to study art and craft (technology).

At Coventry School of Art (then in the process of becoming Lanchester Polytechnic), people from the two backgrounds of design and fine art were able to meet in computing. Clive Richards, who came from a technical illustration background, worked with Ron Johnson, Head of Computer Science, on an Elliott 803. In 1970, writing in Algol, Richards created *Spinning Gazebo*, a three-dimensional wire frame representation of a gazebo rotating in space and the first computer animation produced in a British art school. (fig. 2) Richards later created the CACTI (Computer-Aided Construction of Technical Illustrations) software package.[18]

In 1968, the conceptual art group Art & Language (A&L) began at Coventry, taught by Terry Atkinson, Michael Baldwin and Dave Bainbridge. One of their students, Graham Howard, became interested in cybernetics and excited by 'the idea that art wasn't just painting and sculpture, but could be something else entirely'.[19] A&L became a body of activity, which did not have any output to computer graphics, but its more conceptual aspects, based on computational methods, certainly tuned into the same notions of technology. A&L's *Index* which was exhibited in *New Art* at the Hayward Gallery in 1972, represents the first full manifestation of their endeavours to develop a second order, or meta level, of discussion about their conversation, using 'markers' ('tags' in today's computer terminology) as a way of making data searchable. Conversational analysis and mapping, using a logic-semantic sieve or grid with a range of modalities, indicated a potential for the future in computing.[20]

In 1983 the Electronic Graphics Course was set up at Coventry. At a time when mainframes were considered the best way to do things, it was the art and design

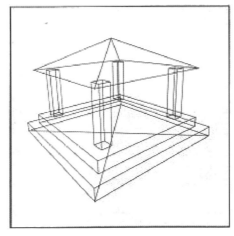

*Fig. 2. Clive Richards. A still from* Spinning Gazebo, *1970.*

studio equipped with a PLUTO II frame store which was essentially the first to have personal computers in the institution. This introduced the idea that large groups of students could work on affordable computer hardware, and that graphics could be produced to at least television standard.

At Coventry, artists and designers inserted themselves into computing, but at Middlesex, it was the converse – a programmer recognised the opportunities and inserted himself into the art community. John Vince, a programmer before becoming Lecturer in Data Processing, was in charge of the Honeywell 200 computer and a rare 12" Calcomp 565 plotter. In 1973, Middlesex Polytechnic was formed from Enfield College of Technology, Hendon College of Technology and Hornsey College of Art. Vince taught languages – Basic, Fortran, Cobol – as well as computer technology to students studying a wide variety of courses. He realised that artists and designers were interested in this device, and that they did not necessarily want to write high-level programming. He developed one of the first packages for artists – PICASO (Picture Computer Algorithms Subroutine Orientated) (fig. 3). Written in Fortran, he was forced to drop the second 'S', due to the language's six-letter rule for names.

During this period, Vince would visit Hornsey's Cat Hill campus, writing PICASO on a blackboard with chalk and indicate to students how they could control the size and position of their images and the nature of the shading effect. Students, in turn, would copy down the program, which included their own modifications, onto coding sheets, which he then took back and ran through the computer. Artists who worked with him at Hornsey include Darrell Viner and Jullian Sullivan (both of whom later went to the Slade). In the late 1970s, Vince and his colleagues ran training courses for the television industry, teaching graphic designers who were new to computing how to do animation in a short one-week course.[21]

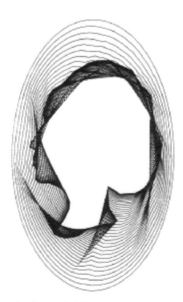

*Fig. 3. John Vince. A face created using PICASO, mid-1970s.*

By 1980, PICASO contained about 500 subroutines and together with its complementary rendering system PRISM was being used by over 25 academic institutes in the UK. In 1985, with a grant from the Thatcher government, Middlesex became the National Centre for Computer-Aided Art and Design under Paul Brown, a graduate of the Slade's programme. By 1986, Middlesex had secured an international reputation for computer animation, setting up the UK's first MSc course in Computer Graphics. In 1988, the Centre was headed by John Lansdown (it was later named the Lansdown Centre), an architect by profession and major pioneer of computer-aided design and graphics.

It is somewhat surprising that computer arts should have prospered at the Slade during this early period. As discussed earlier, the beginnings of the application of technology to the arts took place mostly in provincial institutions within the context of design and the applied arts. However, a brief look at the founding history of the Slade indicates that as an institution it was sympathetic to new art forms. The foundation was made possible by a bequest from Felix Slade in 1871, who envisaged a school where fine art would be studied within a liberal arts university.[22] The first Professor of Fine Art was Sir Edward Poynter.[23] Trained in Paris, he introduced the more open and creative methods employed by the French Academy system, which had less distinction between fine and applied art. The Slade has a long tradition of educating fine artists including, around the turn of the century, Wyndham Lewis, the most prominent of early British modernists. Hamilton, Eduardo Paolozzi and other members of the Independent Group had attended the School in the 1940s. Perhaps, tellingly, Coldstream, educational reformer as well as artist and film-maker in his own right, was Professor of the Slade during this period (1949–1975).

The pioneering computing curriculum at the Slade was founded in 1972 by Malcolm Hughes as Head of Postgraduate Study. As a member of the Systems group from Chelsea School of Art, Hughes employed various, frequently mathematical, systems to provide ordering and structural principles to his work – predominantly realised in painting.[24] This Renaissance concept of the arts postulated that artists could be scientists too. Hughes was also a great enabler and facilitator who realised that he could get more money into the Slade by broadening its base. Drawing on the European vision of arts and sciences and the Bauhaus example, he believed that the Slade could play a greater role and thereby gain respect for fine art within the university system. Film-maker Chris Welsby joined the course in 1973, because he 'wanted to be part of the University'.[25] In fact, Welsby did some work with the Astronomy Department. Also during this period, Viner created animated films using the University College London mainframe, which could output direct to 16 mm film.

The Slade's Department of Experiment was largely driven by Chris Briscoe, a technician/tutor at that time and a brilliant engineer. He taught Fortran programming and circuit building, in addition to constructing a large, $8 \times 8$ foot XY plotter and persuading the department to purchase a Data General mainframe (which he later customised). Eventually, Briscoe designed his own 35 mm slide scanner so that he could integrate computer-generated images with live action[26] (fig. 4).

Scrivener was influenced by the ideas and work of the Systems group, many of whom visited the Slade as tutors. He saw that formalism offered great control over

*Fig. 4. Computer equipment at the Slade, c.1977. Photo © Paul Brown.*

image making, and with programming, he thought 'here is a system that can implement systems'.[27] Assisted by Briscoe, Scrivener built all of the computer hardware and programmed it for his Higher Diploma Show work. (fig. 5) The Slade's course ran until 1981.

Efforts in educational institutions impacted upon technological developments in the wider world. As the polytechnics had the equipment and the practitioners within had the expertise, they took on commercial work for advertising agencies and clients such as BBC Television. During the 1970s and 1980s the field started to grow

*Fig. 5. Stephen Scrivener,* The Machine. *A degree work from the Slade, 1974.*

commercially. Computer animation techniques in particular were in high demand. Some pioneers migrated from educational institutions to found commercial production houses. Digital Pictures was formed by Brown and Briscoe, initially in partnership with the Slade, as a way of running and maintaining the computer there. System Simulation was founded in 1977 by Mallen (who had worked with Gordon Pask) and Lansdown, both founder members of the Computer Arts Society in 1969. System Simulation worked on computer-generated projects such as graphic elements within Ridley Scott's motion picture *Alien*. Although part of the service industry, such ventures were also important places of research and development while their participants continued to make art and, in some cases, teach. Other pioneers were involved with artist-led initiatives and some held down day jobs in the computing industry. In this way crucial links between the upcoming generation and the latest technological developments were created.

## Conclusion

In the early days, the notion of working with computers as an artist was quite ground-breaking. Almost the only access to computers for artists was in academic institutions. Out of this grew modest commercial work for clients such as the BBC. Although the polytechnic hierarchy was generally fairly receptive to computer work, occasionally even introducing concepts like 'study leave' for its practitioners, by the late 1970s, it became clear that the level of investment these institutions could make could not match that made by the commercial sector. With changes in institutional management, it was all too easy for projects to find that they no longer fit the remit and, therefore, close down.

Historically, Britain has had a fairly conservative attitude towards modernist art practices. It is not surprising therefore that by the mid-1970s, computer arts activity had gone largely independent. This is generally owing to the nature of computer arts itself and its problematic relationship with the institutional structure of the art world. The creation of artworks by practitioners without formal art school training made it difficult for the field to be embraced wholeheartedly in an official capacity.

However, it continued largely unseen, outside the mainstream art world of the dealer and gallery networks. Partly because of this, many of the pioneers discussed in this paper continued their careers as academics or set up commercial ventures where they remain today, manipulating technology and continuing to influence upcoming generations. The cross-disciplinary work of this period had a lasting impact on arts education, particularly with regard to notions of freedom of materials as well as a manner of working which takes into account the relationship between artist and audience, and material and environment.

The commercial sector developed its own approach and venues for practice and exhibition, for example, America's SIGGRAPH annual conference and exhibition (SIGGRAPH is the special interest group in graphics of the Association for Computing Machinery (ACM)). This tended to overshadow artistic developments until the late 1980s when a renewed enthusiasm may be seen with the rise in popularity of New Media art. The lack of direct connection between this pioneering

period and the start of, for example, Net Art in the 1990s is in itself interesting. Net Art was more involved with the computer as a platform for communications and issue-based ideas, sometimes deconstructing the technology itself, whereas early computer arts were about specificity of material and technique.

Much of the technology used by pioneers became ubiquitous. It may now be rare for artists to be taught programming, but many of the pioneers' ideas became integrated into the mainstream – the rise of proprietary software such as Adobe Photoshop means that one no longer has to write code to achieve many similar effects. However, the interactive, responsive aspects of much early computer art continues to dominate contemporary New Media-based practice.

## Notes

1   Frayling, C. (1987), *The Royal College of Art: One Hundred and Fifty Years of Art and Design*, London, Barrie & Jenkins, p. 9.

2   Massey, A. (1995), *The Independent Group: Modernism and Mass Culture in Britain 1945–1959*, Manchester and New York, Manchester University Press, p. 54.

3   Alloway, Banham, Lewis (1956), *This is Tomorrow*, London, Whitechapel Art Gallery, Section 12.

4   Hamilton, R. (1981), 'About art teaching, basically', *Motif*, 8: winter, pp. 17–23.

5   Ascott, R., interview with author, 2 September 2003.

6   Strand, R. (1987), *A Good Deal of Freedom: Art and Design in the Public Sector in Higher Education, 1960–1982*, London, Council for National Academic Awards, pp. 9–10.

7   Metzger, G., interview with author, 11 July 2003.

8   Ascott, R. (1961), 'Introduction to the Ground Course', *Prospectus,* Ealing Art School, no page numbers.

9   Willats, S., interview with author 6 July 2004.

10  Willats, S. (2000), *Art and Social Function*, London, Ellipsis, p. 15.

11  Willats, S. (2001), *Beyond the Plan: The Transformation of Personal Space in Housing,* Chichester, Wiley-Academy, Introduction.

12  Cornock, S., interview with author 9 March 2004.

13  Pountney, A. (1971), 'Opening address', *Creativity in a Machine Environment*, Leicester, City of Leicester Polytechnic, p. 2.

14  Stonyer, A., communication with author 10 April 2003.

15  Scrivener, S., interview with author 4 November 2003.

16  Reichardt, J., interview with author 13 February 2003.

17  Government White Paper 'A Plan for Polytechnics and other Colleges: Higher Education in the Further Education System', 1966, quoted in Strand, R. (1987), *A Good Deal of Freedom*, London, Council for National Academic Awards, p. 54.

18  Richards, C., interview with author 22 July 2003.

19  Howard, G., interview with author 22 October 2003.

20  Richards, C., interview with author 22 July 2003.

21  Vince, J., interview with author 5 June 2003.

22  The Quality Assurance Agency for Higher Education, *Subject Review Report, University College London (The Slade School of Fine Art)*, Dec 1999 http://www.qaa.ac.uk/revreps/subj_level/q101_00.pdf (active November 04).

23  *A Brief History of the Slade*, www.ucl.ac.uk/slade/aboutus/history.html (active 5 October 2005).

24  Scrivener, S. communication with author October 2004.

25  Welsby, C. interview with author 2 October 2004.

26  Vince, J. communication with author October 2004.

27  Scrivener, S. communication with author October 2004.

# Learning Resources for Teaching History of Art in Higher Education

Jutta Vinzent

## Introduction

The selection of appropriate learning resources for teaching History of Art in higher education (HE) has been little examined so far. This is particularly surprising since the subject relies heavily on images. Apart from K. Cohen and other scholars teaching in the United States who have reflected on the subject, a major contribution is Paul Brazier's annotated bibliography covering British and American publications up to 1979.[1] However, most of the literature mentioned by him deals with the contents of teaching rather than with teaching methods. In recent years, some attention has been paid to the use of ICT (Information and Communication Technology) in the discipline, particularly by the British-based CHArt (Computers and the History of Art) founded in 1985 and the German publishing house *Wissenschaftliche Buchgesellschaft*, which also published a book for art historians in its series of introductions to the Internet in 1999.[2] This paper examines e-learning and other resources for teaching History of Art in HE in Britain and aims to draw attention to this ever-expanding field.[3]

This paper discusses resources used in a three-hour module which I taught at the Department of History of Art, School of Historical Studies, University of Birmingham over two terms to second-year undergraduates (joint honours) in 2001 and 2002. The module, a chronological survey of modern and contemporary art, was attended by a number of home, overseas and visiting students. From the large variety of resources used during the module, the following will be examined: slides and digital images; trips to galleries and museums and ICT resources (Internet and intranet).

## Introduction to the Module

The selection of resources was based on the module's objectives, assessments and desired learning outcomes. The objectives of the module were:

> Increase knowledge. To fit in with the departmental policy and the overall course (three-year B.A. joint honours or major/minor), the module-specific objectives in the course outline were laid out as follows: 'The aim of this module is to provide students with a general introduction to significant movements from Surrealism to the present, focusing on art and culture in Paris, London, Berlin, New York, but also Birmingham. We will address issues, such as the shift of art centres, new media, feminism and post-feminism and the dissemination of contemporary art and raise problems of the western canon, such as the concept of linear evolution, insiders and outsiders, transculturation and nationalism in art. Although we will concentrate on paintings and sculptures, attention is also given to graphic art, performance art and photography, video and digital art.'

Improve research skills (writing assessed essays, carrying out original research).

Foster transferable skills (presentation skills and ICT skills).

Improve social skills (through group work and study trips).

In order to evaluate whether these objectives were met, the module was principally assessed by two types of assignments: seminar presentations and essays. The learning outcomes of the module included that the 'students should have learned to apply the basic skills and knowledge acquired in year 1 to the study of specific periods of art history (...). In addition, they should be able to relate the history of art to cognate humanities disciplines.'[4]

My fundamental rationale for the selection and design of all learning resources was to encourage a deep learning approach, so that students can understand ideas and concepts for themselves.[5]

## Slides and Digital Images

History of Art is a discipline based on images. Apart from looking at the originals displayed in museums and art galleries, showing the image when analysing art reinforces key learning points.[6] Slides, which the Art History depended upon for a long time, and digital images, which are slowly taking over, will be discussed here.

Most art history departments in the UK run their own slide library holding thousands of slides accessible to students and staff; as does the department in Birmingham. From the 1950s, 35 mm slides have been standard.[7] Despite many technical problems that can occur when using slides,[8] their advantage is that they allow many people at the same time to conduct formal and stylistic comparisons between works that are not kept or displayed next to each other *in situ*. In 2001 and 2002, the slide projector was usually the medium used by myself and the students during the module. I employed slides for mainly two purposes: to illustrate a lecture/ seminar and as a formative developmental assessment at the end of a seminar. The latter aimed to help students to recapitulate previously acquired knowledge and develop their visual memory. These slide tests were spaced over time and demanded students' activity (students had to identify the image from their memory without referring to notes and respond to a questionnaire) instead of passivity.[9] According to my own evaluation the use of slides increased the students' knowledge and reinforced the oral analysis of the image.

The students' use of slides in seminar presentations was assessed by me immediately after the respective sessions. The students also received written and, often, oral feedback. In general, the quality of the student presentations improved over the year; it had been a good decision to assign a student to undertake two (and thus shorter) presentations during the two terms instead of just one long one. It gave them the chance to improve and realise the extent to which they had made progress since the previous presentation. Many students were positive about the slide test, saying that it helped to jog the memory and that it worked as a revision of previous sessions.

Apart from usually using a slide projector to deliver the one-hour lecture, I once replaced it with a PowerPoint presentation using digital images. In addition to fostering students' ICT skills, I treated this session as an experiment to find out the

difference slides and digital images make in the students' learning experience. For this project, I chose the lecture 'Into a New Millennium' that covered two major contemporary art exhibitions, Documenta in Kassel and the Venice Biennale. The PowerPoint presentation consisted of digital images of the artworks discussed during the lecture. The only text I added were the captions identifying the artwork and its artist.

At the beginning of the lecture, I introduced students to the technical equipment and pointed out that I would be interested in the experience of this kind of teaching. The students evaluated the class by filling in a questionnaire at the end of the session. The results were quite interesting. Generally, the familiarity with the use of PowerPoint presentations seems to depend on where the students came from; unlike the two visiting students from Japan, the home students were not familiar with having their modules delivered as PowerPoint presentations (it was either the first or second presentation which they had ever seen).[10] Most of the students replied that it made no difference to them whether the images were shown by a data or slide projector. As to the advantages of using slides, the students identified the following: (1) slides are safer to use (less technical problems, easier to operate; no compatibility problems between various laptops and data projectors) and thus it is easier to prepare a lecture or a presentation that uses slides; (2) the large format of slides allows for better visual details.

These comments seem to confirm the students' unfamiliarity with PowerPoint and how to prepare a digital image of a size comparable to a slide. My own worry about digital images is that despite the existence of several large image libraries, we do not know how long images will be preserved safely. We do know about the colour of slides fading, but we still have no idea of the lifespan of storage devices such as a hard drive, memory stick or a CD.

The most important advantage of digital images named by the students was the possibility of adding additional textual information (such as the identification of the artwork). This contributes to clarity and better understanding which is particularly important for non-English-speaking students.

Asked whether they would use a data projector, if they had the technical equipment available, students were positive, but reluctant. They would only use this equipment if they were more computer-literate! Asked whether the sessions had increased their ICT knowledge, the students were divided. One of the reasons may be that they thought that they would only learn ICT skills by being taught how to use PowerPoint software in some depth and by using it in training sessions. This, of course, indicates that students need to learn not only word processing, which is a requirement in the Department of History of Art at the University of Birmingham and probably most other departments, but also software that supports presentation. Students should be encouraged to learn ICT presentation skills. To start with, staff should provide information on courses run by the university; the University of Birmingham, for example, runs not only computer courses, but also a website called 'Support for Study Skills' that offers self-study tours for such programmes (http://www.istraining.bham.ac.uk, active 28 January 2006). In future, when the departments are properly equipped, one will have to think about whether ICT presentation skills should become a requirement for studying History of Art.

The questionnaire also brought to light the fact that students would rather use a PowerPoint presentation for contemporary art than for old masters. ICT presentation skills will be useful for any art historian. First, provisions are already there: image libraries offer representations of works of all periods, digital cameras give everybody the opportunity to produce digital images, and most conference rooms are equipped for digital presentations. Second, it was my strong belief in 2002 that in the future, the presentation of art historical papers would change from using slides to digital images,[11] which indeed has become reality. Apart from the problem of not being able to get spare parts for slide projectors that most companies are ceasing to produce and despite the disadvantages named above, digital images offer wider possibilities. While slides can only be used for presentations, the same digital image can be exploited in a number of ways: in presentations both by staff and students, and in written work to show the object and its detail.

Because of the variety of usage, digital images may well be a cheaper option in the long run.

ICT presentation skills are not only important for studying History of Art: A student argued that it would be 'useful to know new technology, particularly for later employment'. Indeed, PowerPoint presentations have become standard in the professional world. Furthermore, since even educational institutions have become controlled by finances, 'being up-to-date technologically', as one student formulated it, could promote the reputation of the department.

After having looked at what the students need to learn, critical self-reflection told me that I had to improve my own presentation skills with data projectors in 2002. For less-skilled people like me, the most common surprise is the simple disappearance of images during the PowerPoint presentation owing to forgetting to switch off the computer screensaver. A further task is to think of ways to get the Department properly equipped. Because the technology is still quite expensive, not every department has the hardware necessary for teaching with digital images (data projector, laptop or computer, scanner, etc.) Relying on a centralised ICT service can be nerve-racking, if digital images are to replace slides. For regular sessions it is vital that a department owns the equipment, just as departments currently have their own slide projectors.

## Trips to Galleries and Museums

Although the Department is located within the Barber Institute of Fine Arts, we still undertake study trips locally, nationally and internationally to increase students' knowledge and research skills, and, above all, to make them aware of the difference between reproductions and real objects; in particular a formal analysis of an artwork relies essentially on seeing the original.[12] Additionally, the museum can let one feel the power of the 'mystique' of original works – that is, a 'sensitizing experience in which one becomes exposed gradually to the unique and evocative properties of original works',[13] a feeling which is even provoked by modern art multiples and art reproductions such as screens by Warhol. Furthermore, study trips motivate students to engage with the subject.[14]

The way I used the study trips also fostered presentation skills; students had to give short presentations in front of the objects. This particular approach is based on a

teacher-student interaction strategy; knowledge, concepts and a broader under-standing are gained through active participation in the teaching process.[15] Study trips also contribute to developing social skills and good working relations amongst the students, which are particularly important for group work. Local trips also involve meeting the museum staff and this may also lead to students undertaking work experience with them in the future.

With these objectives in mind, I planned and undertook a seven-day trip to Berlin at the end of the module (20–27 March 2002), which was compulsory for the stu-dents, and two optional shorter trips distributed over two terms to the City Art Gallery (Waterhall) and the Ikon Gallery in Birmingham. Additionally, the students were offered the opportunity to take up the rest of the places in a bus hired for the first-year undergraduates to visit Tate Modern, London.

For the local trips, the students were asked to look at the exhibition and choose one art object and then present it to the rest of the group with the following questions in mind: (1) Why did you choose this particular piece? (2) How would you describe it? (3) How would you relate it to the rest of the exhibition?

The questions were intended to engage students, who were divided into groups, with the entire exhibition and one exhibit in particular, instead of just walking around aimlessly. Forming groups themselves also teaches self-direction and initiative. In the City Art Gallery and the Ikon Gallery these little presentations were given in the presence of the curator or education officer respectively, who then gave an introduc-tion to the exhibition and answered students' questions. Having first listened to the students' presentations, the curator/education officer was given an idea of the level and interest of the students and could link up with their interests or topics.

The shorter trips meant extra contact hours, despite trying to bring several groups which I taught together for the study trip. Students indicated on their questionnaire, however, that they found the trips stimulating and beneficial to their understanding of issues covered by the course.

In conclusion, the learning objectives as outlined earlier (increase in knowledge and motivation) have been met to some extent. Apart from the timing and a decreasing student attendance during the autumn and spring terms, a reason for not having a more successful outcome could be that I did not fully integrate the feedback on the presentations in the gallery and attendance on the study trips into the module. Timing and feedback have to be considered more cautiously when planning shorter study trips.

As a result of this outcome, I planned the seven-day study trip more carefully. During the week, I was able to give oral group and individual feedback on the development of presentation skills and the increase in knowledge. Students could also give feed-back at the beginning and end of the trip. On the first evening of the trip, I asked the students to comment on my proposed itinerary for the week. This gave them the chance to be involved in the planning; and, indeed, they requested extra sites to visit. At the end of the trip, we had a group review based on the methods of the Nominal Group Technique (NGT) outlined by Lloyd-Jones.[16] One positive point mentioned was the presentations in front of the objects, which made the students engage with the exhibits and encouraged critical thinking by listening to their peers.

The students found the knowledge they had gained about art and its political and cultural backgrounds, and the engagement with the originals, most beneficial. The majority of students were inspired by the seven-day study trip to base their second assignment on works seen during this long trip. They used photographs taken during the trip or/and books with reproductions they had bought. Thus the students learned how to make full use of a gallery visit, and how to search for sources and collect objects of research interest. These basic research skills are particularly important for doing the B.A. dissertation in their following year.

Presentation skills during the trip improved steadily, because of the frequency with which students had to give presentations. This helped to produce a relaxed atmosphere during the presentations in front of the objects and the question/comment session that followed in which students increasingly took part.

Social skills were developed: apart from going out together in the evenings for meals and then to pubs, the students shared and prepared presentations with changing fellow students. It has to be noted that, despite some partying, students regularly attended and actively participated in the daily programme. The success in developing social skills was also due to timing the trip at the end of term, which could be described as the 'performing phase', a phase that comes 'after the forming, storming and norming phases' according to Brown and Atkins.[17] The case study, however, has shown that these phases, contrary to Brown and Atkins, are not hierarchical, but rather interactive and cyclical as proposed by Tuckman:[18] during the study trip the students redefined their roles as a result of getting to know one another even better.

## Use of ICT Resources

ICT resources were used in order to increase students' knowledge and improve their research and IT skills. Three different practices will be analysed here: the Internet as a research tool and as a primary source, and the use of the departmental intranet for computer-assisted learning.

### The Internet as a Research Tool

The students used the Internet for the acquisition of primary and secondary sources. They included website addresses in their handouts supporting seminar presentations and in the bibliography of the assignments; apart from using the Internet (search engines, image libraries, websites), the students accessed the online library catalogue of the university and the union catalogue COPAC. The students, particularly those who gave seminar presentations on contemporary topics or artists, used the Internet as a resource for finding information and getting images. They usually printed them out and converted them into slides because the teaching room was not equipped with a computer and did not have Internet access at the time the module was taught.

There is an increasing number of web image libraries and gateways to art available online. At the time of writing the Department has just received the necessary equipment to make digital images available to students. Teaching with digital images, both on- and offline, will enable 'students to study [...] on their own schedules, and contact

time is used for discussion rather than delivery of information, a technique that led to the development of higher cognitive skills'.[19]

Despite the advantages, one has to draw students' attention to the fact that the Internet, although it offers endless information, still has no quality control[20] and thus could provide unreliable results. Information skills include not only the ability to locate and retrieve relevant resources, but also to evaluate them. Thus, I created a gateway on my website[21] that gave students a first direction (including subject-specific sites, image libraries and websites of major museums). The websites listed there had to pass the evaluation criteria proposed by Judith Hegenbarth: [22]

Content analysis (reputable)

Appropriateness (giving the correct level)

Coverage (unique or historical)

Relevance (whether it adds value)

Accessibility (no password required, for example)

Usability (ease of navigation)

Data reliability (quality control)

Technical reliability an maintenance

The experience of using the Internet for learning showed that it fosters students' self-direction and student-centred learning.[23] The evaluation by the students after the module (in the form of a questionnaire) revealed that most students frequently used the Web to find resources; some students found the Web to be more up to date than books. The Internet was widely accepted and used by the students in this specific module, which also included sessions on (what can widely be termed) computer art.

## The World Wide Web as a Primary Source: Computer Art

As international art exhibitions such as the Venice Biennale 2001 have demonstrated, computer art and, more specifically, Net Art have become increasingly popular. Thus, I included a week dedicated to this new medium in the module on modern and contemporary art. The Web formed the primary source for a lecture on computer art and a seminar on digital and Net Art.

While, as usual, the lecture took place in the photograph room of the Barber Institute, the seminar on computer art and Net Art, following a student's initiative, was held in a computer room. The lecture gave an introduction to the history of computer art encompassing art produced with a computer (e.g. by Joseph Nechvatal) and online art with its features of movable images, interactive features and hyperlinks. The subsequent seminar consisted of two student presentations. The first one, covering digital art, started with an introduction to the subject. Then the student giving the seminar presentation divided the group into two and gave them time to answer questions on specific websites representing digital works and Net Art. These questions were aimed at finding out specific features of Net Art and were thus intended to deepen the knowledge gained in the lecture on the previous day. The second seminar presentation was on 'Searching the Net', a vague title that

was intended to leave the specific topic open to the student. In a meeting prior to the presentation, the student had chosen 'digital galleries' with the aim of distinguishing between those websites offering a digital tour through their real museum and Web galleries which only exist in virtual space. The group, divided into pairs, was given indications of websites and time to answer questions in line with the objectives of the seminar. Both presentations allowed the students to surf the Internet.

Sitting in a computer room changed the teaching situation; whereas usually we assembled around a table, here we were sitting in rows in front of computers. Less attention was therefore paid to the student who was giving the presentation, because the fellow students were distracted by the computer in front of them (students played around, particularly at the end of the session, when the presenter summarised her arguments).

The students' response at the end of the module to the question as to whether the sessions on computer art have increased their knowledge about the Web showed that a number of students seemed to think that they mainly gain knowledge when they are actively involved in the process of teaching and learning, not by just listening to a lecture or sitting in a seminar presentation on computer art in front of a computer.

## The Intranet for Computer-Assisted Learning (CAL)

The departmental intranet (http://www.historyofart.bham.ac.uk/, password required, active 28 January 2006) is used for CAL. I posted information for the students here after the session with the aim of making them familiar with the departmental intranet and encouraging them to access the site, apart from deepening the knowledge gained in the sessions. This was at a time when WebCT (now WebCT Vista), a program especially designed to support teaching, was not widely available on campus.

In the second half of the autumn term, the intranet was used three times for the publication of work produced by the group in the seminars. These consisted of students' presentations, each analysing the work of an artist that was relevant for the art movement discussed in the lecture on the previous day. As part of the requirement, the presenters had to involve the whole group. These sessions were on Christo and Jeanne Claude, Joseph Kosuth and Yves Klein who were discussed in relation to Environment/Land/Earth Art, Conceptual Art and Happenings and Fluxus, three movements/styles of the 1960s and 1970s all sharing the questioning of art as an object. The students giving seminar presentations divided the group into two and asked each to create an object that resembled those of the artist in question. This and questions that accompanied the task were meant to initiate thinking about the particular artwork, its production and meaning. The physical results of the group work were then photographed with a digital camera and put on the intranet under 'Survey course – News'. In the following. A more specific description of one of the groups is given as an example.

Based on the project of the Reichstag building in Berlin which the artists Christo and Jeanne Claude wrapped in 1995, two groups had to do the same with an object in the room that they found appropriate. One group wrapped the slide projector and the

screen on which Christo's *Wrapped Reichstag* of 1995 was still visible, the other wrapped a slide that showed the Reichstag in the 1930s. Both groups tried to copy the artists with wrapping objects related to their work. Like the artists, who had to unpack the Reichstag at the end of the project-phase, the students had to uncover the objects again. The photographs taken were the only proof of the time-specific artwork. These basic imitations of the artworks made clear to the students in a practical way a central issue of art works being time- and place-specific. The experience continues on the intranet; it drew attention to the saleability difficulties that land/urban artists such as Christo and Jeanne Claude face when their objects 'vanish'. Indeed, the artists sold signed photographs and sketches after the Reichstag was unwrapped.

Students enjoyed these seminar presentations which encouraged deep learning owing to the students' active involvement.[24] The photographs posted on the intranet provided additional benefits: they could be accessed by students any time via terminals on the campus, enhancing students' motivation to contribute to the departmental intranet. The use of ICT enhanced students' transferable skills.

All these benefits underline the importance of e-teaching that actively involves the students. Through the use of WebCT Vista (http://webct-cluster.bham.ac.uk/, password required, 28 January 2006) and similar products such as Academici (https://www.academici.com, active 28 January 2006), students gain unrestricted remote access to course-related material. This is important for students who go home during college vacations and others, mainly postgraduates, who do not live at the place where they study. Moreover, these programmes support student-centred learning, since they allow them to upload their presentations (which was not possible with the intranet) and offer communication tools with which students can discuss topics set either by the tutor or themselves.

## Conclusion

There is no doubt that the Web will be used even more for teaching and learning in the future. However, as seen above, the use of ICT resources needs appropriate technical support that was at a minimum in our department, when the case-study module was taught. As Joinson and Buchanan suggest, ICT will not 'simply enhance students' learning', it 'might introduce new ways of learning' that, as shown above, may be more student-centred and self-directed.[25] The role of the tutor is still seen as a potential source of expertise, although I believe that the tutor will become more of a facilitator and moderator; he/she will be the one who eases access to the appropriate information sources and enhances their usage.

In conclusion, on the basis of a variety of evaluation methods (questionnaires, informal feedback, assessment, attendance, NGT) conducted by various people (mentor, students, colleagues and myself) the above analysis concerning resources has shown that the following factors promote success in terms of meeting the desired learning outcomes:

When resources require students' active involvement and when this is made public and supervised (e.g. oral presentations in front of their peers as opposed to looking at the intranet privately), active involvement, indeed, encourages a deep learning approach.[26]

Learning is more successful when part of a student's life experience, and not only based on sitting in a classroom, or taking part in intensive study trips. This may be the reason why traditional universities were founded as a living and working community and still function in this way today.

To be prepared technologically for teaching History of Art in the future, students' and lecturers' ICT knowledge and skills have to be revised and departmental equipment improved.

## Notes

1   Cohen, K. (1997), 'Digital Culture and the Practices of Art and Art History', *Art Bulletin,* vol. 79, no. 2, pp. 187–216; Brazier, P. (1985), *Art History in Education. An Annotated Bibliography and History*, London.

2   *Internet für Kunsthistoriker. Eine praxisorientierte Einführung*, ed. Richard, B. and Tiedemann, P. (eds.), (1999), Internet für Kunsthistoriker. Eine praxisorientierte Einführung, Darmstadt.

3   Indicative of the current trend is the Art, Design, Media group of the HE Academy (formerly Art, Design and Communication of the LTSN) which has expanded its resources immensely. Their bibliography of pedagogic research into this field has now 367 titles compared with only a few in 2002 (http://www.brighton.ac.uk/adm-hea/html/home/home.html 16 November 2005).

4   Department of History of Art, Information for Joint Honours Students, 2001/2, University of Birmingham, 6f.

5   Gibbs, G. (1992), *Improving the Quality of Student Learning,* Bristol: Technical and Educational Services Ltd, p. 2; Entwistle, N. (1997), 'Contrasting Perspectives on Learning', *The Experience of Learning*, p. 19.

6   Gough, J. (1996), *Developing Learning Materials*, London: Institute of Personnel and Development, p. 144.

7   Cohen, K. (1997), 'Digital Culture and the Practices of Art and Art History', *Art Bulletin*, vol. 79, no. 2, p. 187.

8   Sloane, P. (1972), 'Color Slides for Teaching Art History', *Art Journal*, vol. 31, no. 3, spring, pp. 276–80.

9   Chalmers, D. and Fuller, R. (1996), *Teaching for Learning at University. Theory and Practice*, London: Kogan Page, p. 59.

10   There is an interesting change which has taken place since 2001 and 2002 when this study was carried out. The first form filled in for the students' personal tutorials indicates that the number of first-year students reading History of Art at the University of Birmingham who have acquired IT presentation skills at school has increased substantially.

11   See Vinzent, J. (2002), *Describe and discuss the design and/or selection of appropriate learning resources for teaching sessions* including appropriateness of ICT, unpublished essay submitted as part of the requirements for the Certificate in Teaching in Higher Education, University of Birmingham, September.

12   Sloane, P. (1972), 'Color Slides for Teaching Art History', Art Journal, vol. 31, no. 3, spring.

13   Johnson, J. R. (1971), 'The College Student, Art History and the Museum', *Art Journal*, vol. 30, no. 8, spring, p. 263.

14   Fallows, S. and Ahmet, K. (1999), 'Inspiring Students: An Introduction', *Inspiring Students*, p. 2.

15   Gibbs, G. (1995), 'Changing lecturer's concepts of teaching and learning through action research', in: *Directions in Staff Development*, Buckingham, pp. 21–35.

16  Lloyd-Jones, G., Fowell, S. and Bligh, J. G. (1999), 'The Use of the Nominal Group Technique as an Evaluation Tool in Medical Undergraduate Education', *Medical Education*, 33, pp. 8–13.

17  Brown, G. and Atkins M. (1988), 'Effective Small Group Teaching', *Effective Teaching in Higher Education*, London, pp. 59f.

18  Tuckman, B. W. (1965), 'Development Sequence in Small Groups', *Psychological Bulletin*, 63, pp. 284–499.

19  Cohen, K. (1997), 'Digital Culture and the Practices of Art and Art History', *Art Bulletin*, vol. 79, no. 2, pp. 187–216; Brazier, P. (1985), *Art History in Education. An Annotated Bibliography and History*, London.

20  Already Cashen, T. (1995), 'The Internet and Art History: A Tool or a Toy?, Computers *and the History of Art*, 5:2, p. 16.

21  My gateway is not needed any more, since the Resource Discovery Network (www.rdn.ac.uk, active 2 February 2006), a search engine and subject gateway compiled by educational and research organisations (and thus refereed), has now included History of Art.

22  Judith Hegenbarth, unpublished paper given in the context of the Postgraduate Certificate in Teaching in Higher Education, Learning Development Unit, University of Birmingham, 4 July 2002.

23  Hammond, N. and Trapp, A. (2001), 'Web Support for the Learning of Psychology', *Learning and Teaching on the* World Wide Web, Wolfe, C. R., (ed.) San Diego p. 166.

24  Gibbs, G. (1992), *Improving the Quality of Student Learning*, Bristol: Technical and Educational Services Ltd, p. 11.

25  Joinson, A. N. and Buchanan, T. (2001), 'Doing Educational Research in the Internet', *Learning and Teaching on the World Wide Web*, ed. Wolfe, C. R., San Diego: Academic Press, p. 238.

26  Gibbs, G. (1992), *Improving the Quality of Student Learning*, Bristol: Technical and Educational Services Ltd, p. 11.

## Further Reading

Brockbank, A. and McGill, I. (1998), *Facilitating Reflective Learning in Higher Education*, Buckingham: Open University Press.

Brookfield, S. E. (1995), *Becoming a Critically Reflective Teacher*, San Francisco: Jossey-Bass.

Collins, J. (1997), *Teaching and Learning with Multimedia, London Contemporary Art and Multicultural Education, Cahan, S. et al (eds), New York: London: Routledge.

Cox, B. (1994), *Practical Pointers for University Teachers*, London, Philadelphia: Kogan.

Dweck, C. S. and Leggett, E. L. (1988), 'Social-Cognitive Approach to Motivation and Personality', *Psychological Review*, 95, 256–273

*The Experience of Learning* (1997), Marton, F., Hounsell, D., and Entwistle, N. (eds) Edinburgh: Scottish Academic Press.

*Flexible Learning in Higher Education* (1994), Wade W. et al (eds), London: Kogan Press.

Forsyth, I. (1998), *Teaching and Learning Materials and the Internet*, London: Kogan Page.

Higgins, C., Reading, J. and Taylor, P. (1996), *Researching into Learning Resources in Colleges and Universities*, London: Taylor and Francis.

Hodgson, M. (1995), *Teaching and Learning in Higher Education. The Integrative Use of IT Within*, Durham: IT Service Durham.

*Inspiring Students: Case Studies in Motivating the Learner* (1999), S. Fallows and K. Ahmet (eds), London: Kogan Page.

*Motivating Students* S. Brown et al., (eds.) (1998), London: Kogan Page in association with the Staff and Educational Development Association.

*Resource-Based Learning* (1996), Brown, S. and Smith, B. (eds), London: Kogan Page.

Stein, S. D. (1998), *Learning, Teaching and Researching on the Internet: A Practical Guide for Social Scientists*, Harlow: Addison Wesley Longman.

Stephenson, J. (ed.) (2001), *Teaching and Learning Online. Pedagogies of New Technologies*, London: Kogan Page.

Thompson, B. (1979), 'Television and the Teaching of Art History', *The Oxford Art Journal*, October.

Wilks, M. and Gibbs, G. (1994), *Course Design for Resource Based Learning. Art and Design*, Oxford: Oxford Centre for Staff Development.

Wisdom, J. and Gibbs, G. (1994), *Course Design for Resource Based Learning in Humanities* (1994), Oxford: Oxford Centre for Staff Development.

## Annotated List of Websites

All active on 28 January 2006

1. General

http://www.ilt.ac.uk (British Institute for Learning and Teaching, now the Higher Education Academy)

http://www.hefce.ac.uk (Higher Education Funding Council)

2. Subject-specific resources

http://www.brighton.ac.uk/adm-hea/html/home/home.html (Learning and Teaching Support Network for Art, Design, Media including History of Art)

http://www.artcyclopedia.com/ (searches art museum sites for exhibits and artists)

http://arthist.cla.umn.edu/aict/html/ (a free-use image resource, but ends with Expressionism)

http://www.artlex.com (Dictionary of Visual Art)

http://artsweb.bham.ac.uk/arthistory/ (departmental intranet)

http://ilpi.com/artsource/general.html (provides an annotated gateway to general resources and bibliographies)

http://www.adam.ac.uk/ (service that helps to find useful, quality-assured information on the Internet, partly funded by the AAH)

http://artresources.com/ (provides links to galleries, contemporary artists, image catalogue)

http://www.chart.ac.uk/ (Computers and the History of Art, CHArt, is an open society interested in the application of computers to the study of art and design)

http://witcombe.sbc.edu/ARTHLinks.html (hyperlinked lists to world art divided by period)

http://www.arts.gla.ac.uk/CTICH/arthistlinks.htm (links to art history resources including Art History gateways, image libraries, themed exhibits and collections, online catalogues, organisations and teaching and student projects)

http://www.library.yale.edu/Internet/arthistory.html (directories to resources, professional organisations, electronic discussion groups, history of art departments, art museums, electronic resources and journals; with an American focus, maintained by Yale University library).

# Sourcing the Index: Iconography and its Debt to Photography

Colum Hourihane

There can be little doubt as to the enormous debt that the Index of Christian Art owes to photography. It is one that is rarely acknowledged and often taken for granted and yet it lies at the very core of the archive. This paper will attempt to redress that situation and will first look at the historical use of photographs in the archive before focusing on how that approach has changed over the last ten years.

Art history is a visual world in which surrogates of what are being studied are frequently used. These can range from black-and-white photographs to slides, transparencies or digital files. First-hand experience of the works of art is rarely accomplished in the classroom, although attempts are now being made to recreate virtual tours of both monuments and galleries, or individual works by means of three-dimensional modelling.[1] No such developments existed at the start of the twentieth century when Charles Rufus Morey, art historian, diplomat, adventurer and chairman of the Department of Art and Archaeology (fig. 1) visited the Bibliothèque Ducet in Paris to view a photographic archive. This archive was not arranged on the traditional basis of school or period or style but was accessed instead through iconography or subject matter; in which, for example, landscapes and portraits were separated and religious subjects were divided from the secular.[2] Upon his return to Princeton, inspired by such a structure, Morey began to arrange his collection of images – postcards, photographs, cuttings from newspapers etc. – into meaningful iconographic divisions and thus the Index of Christian Art was born. It is officially credited as having been founded in 1917. Iconographical classification, which is the strength of the Index, was initially driven by the availability of images. This must have led the first director and all subsequent ones up to 1955 (the year of Morey's death) to claim at five-yearly intervals that they would have catalogued every known work of medieval art. Up until five years ago nearly every image in the Index was derived from publications. At the turn of the century there were few monographs on medieval art published every year and there were even fewer journals devoted to the subject. Today, the number of monographs and journals on the period published in one week alone more than equals all such publications in a single year when the Index was founded.

The Index was the passive repository of whatever had been published – a source that was occasionally augmented by individual scholarly collections of images or rare expeditions to the sites themselves, although the distance from the United States to Europe (and beyond in many cases) must have proved to be a significant barrier. The Index was largely dependent on published images and as such was at the mercy of whatever scholars chose to study. Coverage could be sporadic and it was rare to find an entire manuscript reproduced or to get all the details of the façade of a cathedral illustrated so that the scholar in the Index could identify exactly what was

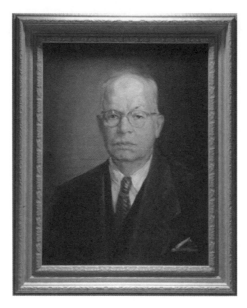

*Fig. 1.* Charles Rufus Morey (1877–1955). *Portrait by Ulyana Gumeniuk. Index of Christian Art, Princeton University.*

represented. Even though the Index has always aimed for comprehensiveness, it was dependent on what was reproduced. This has now changed and it is clear that the whole world of art history is well into the phase of documentation in which large and comprehensive image banks are at our disposal. The fact that the Index did not have complete coverage of every work seemed not to hinder scholarship too much.

The approach of the scholars in the Index was dependent on what they could see in these images. Magnification glasses were used extensively along with the descriptions of the works that accompanied such visual material, but the Index's main contribution to scholarship was always an original evaluation of what was represented. The scholars were never dependent on what somebody else had said. Where works were not illustrated in publications, but where reference was made to them, then a 'temporary' reference to such iconography was included and was not accompanied by any image in the photographic files. This was a less-than-satisfactory situation but one which attempted to be inclusive.

Accessing the images in the Index files was certainly easier than working with the text or iconographic files. Whereas each work was deconstructed textually in terms of its subject matter, and iconographic references were filed under their relevant subject terms (over twenty-eight thousand of them now exist), the visual surrogates were kept together in one file and organised under the basis of medium and then location (fig. 2). To see a folio from one manuscript the user simply had to go to the photographic files and look up under medium (manuscript, for example) and then location (Aachen, for example). It was possible then to examine what was filed under Aachen for all of the collections both private and institutional that had been recorded in the archive. However, to see the iconographical classification text cards for all the folios in that manuscript, it was necessary to go to the relevant subject headings for the

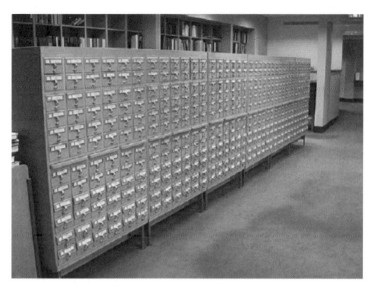

*Fig. 2. General view of the Index files.*

main theme of each folio which could, of course, start with 'A' for the subject term on the first folio and go to 'Z' for the subject matter on the second folio (fig. 3).[3]

From the researcher's perspective it was clear that most followed a near standard approach in that once they had found the images required these were scattered on

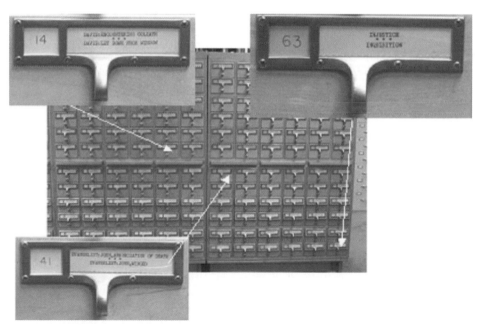

*Fig. 3. Index text files showing the possible breakdown in iconographical classification of a work of art.*

a research table to be looked at, compared and contrasted. In many ways this represented a manual version of the digital gallery format, or the lightbox facility now found in many computer applications.

## Card Index

Once a scholar determined that an image should be included in the Index it was re-photographed and printed on standard size heavy-duty photographic paper, not once, but five times. The four duplicates were then passed on to the four manual copies of the Index, which were distributed in Europe and America. This procedure persisted up to the introduction of computers in 1991. At that stage, as with most archives, nobody knew exactly how many images or text cards were actually in the Index files. It is now estimated there is somewhere in the region of 950,000 file cards on which iconographic descriptions are recorded using twenty-eight thousand subject terms and these are accompanied by around 200,000 photographic cards. The quality of these photographs varies and obviously depends on how good the original was. The quality of photographic prints varied enormously at the start of the last century. All of the images are in black and white as that was the prevalent medium when the Index was being developed. It was also felt by Morey, in his attempts to be as objective as possible, that black and white was the best means to do this. This policy remained unchanged until the late 1990s. Colouration and its significance were described, if relevant, in the textual descriptions but this was not paralleled in the images. The objectivity of these images depended on who took the original photographs and the aims that they fulfilled, but that was a remit which was certainly outside the Index's control. These images represented for Morey the most objective visual response that he could offer to the user. His use of this medium was typical of his stance on the entire process of iconographic analysis, and it is my belief that the Index contributed extensively to the formulation of Panofsky's methodology of subject analysis, which was very much based on the system that had been employed in the Index for some twenty years before his work was published.[4]

The Index has always attempted to improve on its photographic holdings. When a better example of an image already existing in the Index was discovered it was re-photographed and added to the files as, indeed, were any new details of the larger works. Nevertheless, the primary function of these images was always to offer a visual parallel to the description made by the scholar. The images were meant to provide the user with a visual parallel to the textual description, which was the original contribution of the archive to scholarship. Without such an analysis the photographic files were simply that – a large archive of images. Where objectivity was concerned it has to be said that the iconographic interpretation, with its subjective input from the scholar, does make it an unequal situation. It is true that greater scholarship was required in the iconographic analysis than in the generation of images. The images were entirely outside the control of the archive – the Index offered a synthesis of such reproductions. The development and application of iconographic standards, however, was created within the Index and greater input was given to their development to ensure consistency. Whereas objectivity in the creation of images was determined by external sources over which the scholar had little control other than selecting, the Index was entirely responsible for the creation of textual standards.[5]

## Computerisation

For over seventy-five years the Index's collecting policy was largely driven by what was available photographically – a source that was often unacknowledged and not given its due credit. The major break in this policy came with the advent of computerisation. Although late in impacting on the Index, this led to a major change in the use of images and text. Computerisation came to the Index in 1991 when a modified version of a bibliographic standard was first used in the archive.[6] From the outset the policy was to maintain the existing text and image files but also to add to them. This cautious policy was a feature of the early 1980s in that the use of computers was in many ways seen as an experimental phase, which had yet to show its value. All of the existing data elements that could be found on the paper files were reproduced electronically although some new fields were also added. Typical of such additions were fields such as 'Style' and 'School' which were anachronistic to the founders whose aim was to present as objective and non-interventionist a stance to the data as was possible. These new fields in many ways reflected art history in the late 1980s and early 1990s and also catered for a new audience that needed to have such standards included. Like most archives undergoing computerisation, the Index was initially content to focus on the textual record and this was to last for many years without any image component. It was felt that the inclusion of a bibliographic reference to a printed image in the text records was satisfactory and that it would not be too much of a problem for the user to go to the library to get the bibliographic reference to see the actual image. That, of course, assumed that each user had a fully stocked library that would carry the same range of material that the Index had developed over more than ninety years. Image digitisation was begun at the Index in 1998 and heralded a series of major problems regarding the copyright and ownership of the photographs. Whereas the iconographical analysis in the form of the text records was entirely the property of the Index, the rights to the images lay outside of the archive.

User needs demanded that an electronic image accompany the computerised text record and it was realised that the policy regarding images would have to change. The archive was still dependent on the image for generating new material to add to the existing resources. Upon closer inspection it was clear that many of the images that had been collected over the last eighty-five years were now out of copyright and could be offered to users of the database. When we came to digitizing the images, we were able for the first time in the history of the archive to have control over image quality and could vastly improve the archive. Objectivity in this instance was led by our efforts to get the best out of the images and this was achieved by applying international standards in image manipulation. We followed accepted conventions for file size, type, naming etc. Digitisation gave control of these images to the archive for the first time and not just in terms of copyright. Of the 120,000 images that are now available on the Index website[7] and which have been digitised within the last six years, approximately 40,000 have been culled from the existing photographic files. These have been classed as 'Public images' in the database and are accompanied by several thousand for which we do not have copyright and which are 'Restricted' to the Princeton campus. Needless to say our policy is to add to the images that we can offer to the public and this has brought about a number of significant changes in our image acquisition policy which have also impacted on the whole direction in which the Index is moving.

## New Directions

The Index continues to draw extensively from published material and where possible permission is actively sought to make the images of such work available on its website. Such images are no longer added to the existing photographic files but are now digitised only. There have been a number of other significant and recent changes in the image policy of the Index. The Index has started to work collaboratively with a number of institutions who have either image or object collections which are not digitised. The Index has the resources to digitise such archives, make them available on its own website and, in turn, return both text and image records to the owner institutions for their own use. This continues the role of the Index as a synthesis for such material but now it is for previously unpublished material. In the last five years the Index has worked with public and private image collections such as those of Erica Cruikshank Dodd, Peter Harbison, Tuck Langland, James Mills, Gustav Kuhnel, James Austin, The American Research Center in Egypt, Dumbarton Oaks and Mat Immerzeel to name but a few. These collections are digitised and then added to the Index once catalogued.

Paralleling this is an active policy to photograph directly from the works themselves and as such to get copyright and control over what is photographed and how this is done, (fig. 5). This has again led to a number of collaborative and independently funded projects to photograph and iconographically classify collections such as: the Morgan Library, New York; Firestone Library Collection, Newark Museum; the Free Library Philadelphia; The Paul Van Moorsel Centre for Christian Art and Culture, University of Leiden (fig. 4) and so forth. The Index photographer is able to visit such

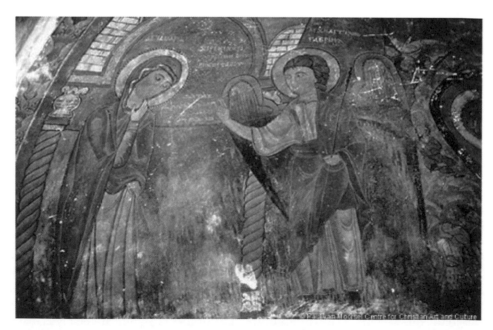

*Fig. 4. Wall painting from Deir-al Surian, Egypt. Photo: Paul Van Moorsel Centre in the University of Leiden.*

*Fig. 5. Churches in Shivta, Israel.*

collections and work directly with the curators in acquiring images for the Index. Another strand to this acquisition policy is the development of a series of studentships in Israel which enable students to visit works in the field, photograph them and then transfer the images to Princeton for inclusion in the database (fig. 5).

Much of this material, whether it is in the Morgan Library or in the Negev Desert in Israel, has never been photographed or iconographically catalogued and as such it has brought the Index into the role of original publisher. The Index has had to adapt and change with the development of new technologies and approaches.

The new policies of the Index include the following: It now has an active policy of photographing from original works of art and has extended its available resources; it has now entered into the role of original publisher and includes visual material that has never before been reproduced; it has entered into the role of collaborator with a number of institutions; it is now able to photograph entire collections; it now uses digital files only (except in the case of the Morgan Library which still continues to be shot in 35 mm slide film alongside the digital format).

The Index no longer restricts itself to black-and-white images and has used colour extensively, especially when photographing from original works of art.

All of these drastic changes which have been developed in the Index in the last six years have changed the role of the photograph in the archive but have not lessened our dependency on it as a source for new material. Now, however, thanks to collaboration we are at liberty to examine the original works themselves and there are very

few 'temporary' files being added. Thanks to image digitisation the Index now offers unparalleled detail in high-resolution large format files. Scholars in the archive are now able to read intricate lettering on their computer screens and to see the most minute features in these images. Computers have replaced the magnifying glass in terms of examining the visual material. In many ways we have now come full circle and instead of being totally dependent on images we can now have an active input into our acquisition policy and an element of control that the Index never before had.

## Notes

1   An example of this is the unique recreation of the Dunhuang Caves in the Gobi Desert now available through the Mellon Foundation sponsored ArtStor site http://test.artstor.org (20 September 2004).

2   See Hourihane, C. (2002), '"They Stand on His Shoulder"; Morey, Iconography, and the Index of Christian Art,' *Insights and Interpretations, Studies in Celebration of the Eighty-Fifth Anniversary of the Index of Christian Art*, Hourihane, C. (ed.), Princeton, pp. 3–16.

3   The best description of the structure of the Index is found in a handbook by Woodruff, H. (1942), *The Index of Christian Art at Princeton University*; with a foreword by Charles Rufus Morey, Princeton, and the more recent article by Ragusa, I. (1998), 'Observations on the History of the Index: In two parts', *Visual Resources*, 13:3–4, pp. 215–52.

4   See Hourihane, C. (2002), '"They Stand on His Shoulder"; Morey, Iconography, and the Index of Christian Art,' *Insights and Interpretations, Studies in Celebration of the Eighty-Fifth Anniversary of the Index of Christian Art*, Hourihane, C. (ed.), Princeton, pp. 3–16.

5   This was particularly important as other archives were using the same standards. The Morgan Library in New York, for example, used the Index standards in cataloguing the iconography of their manuscript holdings. The 1942 publication by Helen Woodruff (*cf.* note 3) encouraged others to follow these standards.

6   The computerisation of the Index and the software employed are discussed on the homepage of the archive at www.ica.princeton.edu (active 20 September 2004).

7   The Index of Christian Art offers its resources on the Internet using a subscription scheme, details of which are available on the homepage at www.ica.princeton.edu (active 20 September 2004). It is now the largest resource for the medievalist on the World Wide Web with many hundreds of thousands of records available.

# The Medium was the Method: Photography and Iconography at the Index of Christian Art

## Andrew E. Hershberger

The discipline of art history depends upon the use of photographs. This should be obvious to anyone who ventures into its academic setting. Slide projectors, slide libraries, collections of digitised photographs and, of course, lavish reproductions in textbooks and journals all typify the study of art.[1] In fact, the attraction that photography still holds for historians of art could be cited as one of the prime motivations for the invention of the new medium.[2] That photography heralded a new dawn for art historians as well as artists was perhaps best expressed by the 'father' of American photography, Samuel F. B. Morse (1791–1872). The famous painter and inventor of the telegraph (who almost invented photography too) penned the following remarks on the impact of photography on the practice and interpretation of art:

> Artists will learn how to paint, and amateurs, or rather connoisseurs, how to criticise, how to look at Nature, and therefore, how to estimate the value of true art. Our studies will now be enriched with sketches from nature which we can store up during the summer, as the bee gathers her sweets for the winter, and we shall thus have rich materials for composition and an exhaustless store for the imagination to feed upon.[3]

The Department of Art and Archaeology at Princeton University was the first academic programme in the United States devoted to the study of art.[4] It is not surprising that this department still shares a building with perhaps the greatest monument to the theoretical and practical relationships between art history, photography, and now digital media that has ever existed: the well-known Index of Christian Art (http://ica.princeton.edu). The Index, founded by Professor of Medieval Art Charles Rufus Morcy in 1917, now contains nearly a quarter of a million photographs of medieval art, and has likewise become one of the largest image databases on the Internet. With four duplicate sets of its photographs at Dumbarton Oaks, the Getty, Utrecht University and the Vatican, the Index is one of the largest collections of photographs and digital images assembled at any time, past or future (http://ica.princeton.edu/location.html). Seventeen different media, including manuscripts, metalwork, sculpture, painting and glass, are represented in the Index. The images are organised by location, with various other primary cataloguing fields such as figures, scenes, nature, objects and miscellany.[5]

A second archive of thoroughly cross-referenced $3 \times 5$ inch cards accompanies this massive body of photographs. According to the Index's website, these text cards 'can presently provide access to complex information on approximately 200,000 photographic reproductions of Christian art in the east and west from early apostolic times

up to A.D. 1400.'[6] The thrust of this 'complex information' is iconography. Literally meaning 'image writing', iconography attempts to answer questions about the theme or subject matter of works of art.[7] Interestingly, these 'subject' cards have always outnumbered the photographs, at times by as much as five to one. Today there are probably over a million cards. The creation of new photographs on paper continues in 2004, but all new text cards have been abandoned for electronic files on each image. As a group, the paper and digital cards offer iconographical data on all the diverse subjects that appear in the artworks, about 26,000 subjects in all 'starting with Alpha and Omega and ending with [Saint] Zwentibold of Lorraine.'[8]

The Index sponsored a commemorative conference at Princeton in 1997 to celebrate eight decades of operation.[9] Distinguished international speakers participated in an intense, two-day event organised by the Director of the Index, Colum Hourihane. The first day focused on the practice of iconography, the second on the theory behind this methodology.[10] As these *foci* indicate, the connection between the Index and iconography runs deep and has been well documented.[11]

As a young and probably overeager historian of photography experiencing this 1997 conference, I could not help but notice that none of the eleven total presentations that I attended on both days explicitly acknowledged nor discussed the fact that the method of iconography, in practice and in theory, depends upon the use of photographs (especially on the scale of the Index). Right then I started to consider why some iconographers felt that photographs of art provide them with an unproblematic source of evidence. Continuing to explore this supposition seemed to me to be an important prerequisite to the theory and practice of iconography, perhaps even to the study of all methods that utilise comparisons and analyses that would be impossible without photographs.

Such an exploration could illuminate aspects of photo theory and digital theory too. For instance, in the most recent history of the Index, published in 1998, author Isa Ragusa claimed that 'there was no model for the method of study of iconography that Morey had in mind' when he started the project in 1917.[12] This claim is not entirely correct. Instead, I would argue that the medium of photography itself was the model for iconography during the first period of the Index's existence. Which brings up the question: Is the new digital medium and the Internet likewise a model for iconography at the Index today and/or in the future? Thus, this paper examines the theory and production of the photographs and text cards in the Index during two periods, focusing on the time when the Index began in the early twentieth century, and then briefly speculating on how or whether it has been transformed within the digital present. As Marshall McLuhan might have said, was and/or is the medium the method?

Charles Rufus Morey (1877–1955) began the project that would become the Index with two shoeboxes as his initial archive.[13] Morey taught his first course at Princeton in 1906 and proceeded to become 'one of the most renowned scholars of the history of medieval art'.[14] He 'led the department toward the study of art as a product of the historical context in which it was produced.'[15] Curiously, Morey's own teaching philosophy might be seen to problematise his initial drive to found the Index. For instance, the topics he recommended to students working on honours

theses make plain 'his view of the importance of contact with actual medieval objects', especially at the Metropolitan Museum in New York and the Princeton University Art Museum. Other faculty in the Department held this view as well, 'demonstrating Princeton's commitment to the ideal method of studying art – firsthand exposure to the objects'.[16]

On the opening page of his foreword to Helen Woodruff's book, *The Index of Christian Art at Princeton University*, published in 1942, Morey stated that the Index 'at first was planned only as a listing of subjects and objects of early Christian art'.[17] Morey undoubtedly meant by 'objects' all the paintings, sculptures, and various other media that to his mind constituted ecclesiastical medieval art. Yet, in his three-page foreword Morey did not mention any of these media. The word 'photograph', how-ever, does appear on the third and last page, when he described the first two photo-graphic 'copies' of the Index made in 1939.[18] He stated: 'The Washington copy includes both subject cards and photographs; in New York only the subject-catalogue was reproduced'.[19] Morey thus left his reader to deduce that the photographs in ques-tion were equivalent to 'object cards' or made up the 'object-catalogue'.[20] Apparently something as 'objective' as a collection of photographs of other artworks required little if any explanation or discussion.[21]

It seems plausible that Morey chose to include photographs in the Index, photographs specifically created for iconographers, because he – like Morse – perceived them to be 'sketches from nature', images that could teach us something about 'how to look' at art. In that sense, Morey used photographs in the Index as 'objective' representations of medieval art. From a photographic historian's point of view, however, one might argue that Index photographs, like all photographs, were and are equally subjective interpretations of the objects they represent. While that critique may apply, I will instead first accept Morey's claim and attempt to determine how this was possible. After all, it is certainly the case even today that many photographs used for art histori-cal purposes, including digital image databases, are still assumed to be at least partly objective. In that sense, this paper should shed some light on the question of whether or not it matters that iconography, digital image archives, and perhaps even art history itself, require the use of such 'objective' photographs.

An approach to these problems can be stated in two questions regarding theory and practice respectively. First, what were the Index's standards for its photographs? Second, how did the Index produce its photographs? Isa Ragusa, the aforementioned Index Reader and researcher, has written one of the most comprehensive essays that touches on all of these issues. In her two-part *Observations on the History of the Index*, she argued that 'the Index material is presented in as impersonal and unprejudicial manner as possible. This requirement of objectivity', as she called it, 'has dictated the basic form of the Index', a form that intentionally 'avoids' 'chrono-logical, stylistic, qualitative, or other judgments'.[22] In fact, Ragusa later named this supposition 'the rule of objectivity'.[23] She likewise stated: 'the Index is set up so that the evidence is presented in as objective a way as possible in the description, and – better yet – by making the visual evidence available alongside the verbal'.[24] Clearly, Ragusa claimed that the photographs were, and/or are, the most objective of all Index materials.

During his tenure as its previous director Brendan Cassidy published several articles on the Index. In the most recent of these from 1993, he identified 'three main sources' of problems for the Index: '1. The nature of medieval art objects. 2. The nature of iconography. 3. Our dependence on photographic images'.[25] However, perhaps inspired by Morey and in turn inspiring Ragusa, Cassidy argued repeatedly that the Index's photographs provide an objective source of evidence:

> If photographs are only a substitute for the real work of art then verbal descriptions are even less satisfactory. Our textual descriptions however accurate or detailed are no substitute for images of works of art. In our descriptions we attempt to convey what the discipline of art history has traditionally deemed are the most iconographically significant features of a work of art. However, what one generation considers significant is not necessarily the same as that which will be significant for subsequent generations.[26]

Thus, Cassidy spelled out one of the benefits of photographic objectivity. Index photographs provide the means for art historians of each generation to check the iconographical descriptions on the Index's subject cards against their own perceptions of an 'objective' representation of each work. In other words, the photographs provide a solution to the problem of the iconographer's own 'period eye'.[27] Rather than simply relying on the accuracy of the description on the subject cards, the 'objective' photographs allow each person to rewrite the iconography using his or her own set of historical biases.

Cassidy's second argument regarding the objectivity of Index photographs revolved around their efficiency in presentation. While describing the ongoing project to digitise the Index, Cassidy predicted that this advantage of objectivity would only be enhanced in cyberspace. 'If I query the database for examples of a particular theme it would make more sense for me to see the answer as images rather than text', he argued. 'Images convey more information. I can choose more quickly and accurately what interests me from a succession of pictures rather than from trying to visualise what works look like from descriptions.'[28] (Most, if not all, image databases are designed this way today, showing a succession of thumbnail images as the 'result' of any particular search.) Here, Cassidy downplayed the usefulness of the subject cards almost to the point where they no longer become helpful sources of information in comparison with the object cards or photographs.

Cassidy's third argument contains the first obvious clue to a standard for Index photographs. 'For iconographers', he argued, 'the expression "God resides in the details", which has been attributed to just about everyone with the power of speech, from Flaubert to Panofsky to Aby Warburg, would accurately sum up the focus of our interests'.[29] The photographic standard for which Cassidy seems to be arguing might be summarised as the *clarity* standard. In order for photographs of works of art to provide access to the level of detailed scrutiny Cassidy desired, the photographs would have to be of a certain sharpness and of a certain size. In any case, Cassidy in general offered strong support to Morey and Ragusa's claim of photographic objectivity.

In 1990, current Index staff member Lois Drewer published an essay entitled 'What Can be Learned from the Procedures of the Index of Christian Art'.[30] Drewer's analysis of the intricate process that has yielded the subject cards hints at another photographic standard at the Index. According to her, the iconographical 'description is written in a rather stylised form of natural language, and considerable effort has been exerted toward consistency in the vocabulary'.[31] Separating herself somewhat from her colleagues, however, Drewer added a statement regarding 'objectivity' that most of the other writers have conspicuously avoided or left to the reader to intuit:

> As we are all acutely aware by now, describing a work of art is not a value-neutral activity, no matter how 'objective' one tries to be. On the simplest level, choices have to be made – about the order in which figures and objects are named; the level of detail to include; for example, costume elements? decorative motifs? colours?; and the degree of interpretation of activities and gestures represented in narrative scenes – are figures conversing? arguing? or merely standing beside one another?[32]

The 'choices' that Drewer identified must have been made during the production of the photographs too, perhaps even some of the same types of questions appeared in both arenas. If encountered often enough, similar decisions for these questions would then have standardised answers or, simply, standards. For example, the efforts to maintain 'consistency' on the subject cards arguably would have crossed over into the photographs as well. Perhaps 'consistency' is another of the standards we seek.

Drewer noted that most of this standardisation occurred at one time in the Index's history. That moment is a crucial one. As she pointed out, 'In the 1930s under the direction of Helen Woodruff a further systematisation of working methods was carried out, and Gothic art up to 1400 was added. The system which had been evolved by the end of the 1930s is basically the one in use today, with of course some modifications of details, and the addition of many new subject headings.'[33] Drewer cited specifically Woodruff's 1942 book, *The Index of Christian Art at Princeton University*. As we recall, Morey contributed the foreword and presumably his stamp of approval. Not surprisingly, their ideas are intertwined in this text.

The aspects of the Index that required explanation in Woodruff's book can be found on the table of contents. There one encounters the following headings: Introduction; Subjects of the Index; Technical Details; Sample Descriptions; Chart.[34] It is telling that Woodruff did not devote a single chapter to the Index's collection of photographs. This absence on the contents page accurately reflects the fact that the book as a whole barely mentions photography.

The subject cards, on the other hand, concerned Woodruff and Morey a great deal. Adding to their emphasis on the table of contents, this can be seen in the fact that Woodruff reproduced only one 'object card' or photograph, her frontispiece, whereas she reproduced ten of the subject/text cards, four of which directly refer to her frontispiece (figs. 1 and 2). It would appear that the subject cards required ten times as much discussion as did the photographs. This ratio finds further support in Woodruff's ten-page introduction, where only five sentences are devoted to the

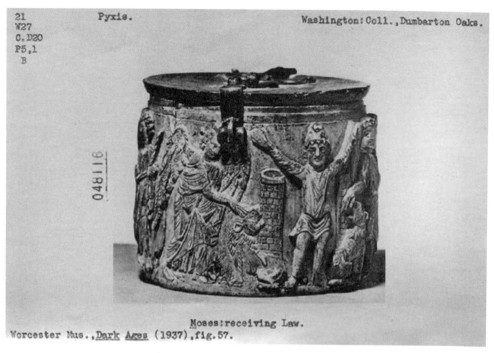

21
W27
C.D20
P5,1
B

Pyxis.

Washington:Coll.,Dumbarton Oaks.

048116

Moses:receiving Law.

Worcester Mus.,Dark Ages (1937),fig.57.

*Fig. 1. Frontispiece to Helen Woodruff,* The Index of Christian Art at Princeton University, *Princeton: Princeton University Press, 1942.*

photographs. The first of these appears separately and describes the procedures that the Index readers or iconographers employed to create the subject cards: 'After reading all important published accounts and noting the identifications, the reader proceeds to describe the monument in purely factual terms based on the visual aspect of the figures in the available photographic reproductions, *without interpretation*.'[35]

While this relative silence and absence of photographs in some ways speaks louder than words, the first mention of the photographs by Woodruff sets the theoretical tone of objectivity that we have heard echoed in later publications. With regard to practice, we can also see an indication of how the process of iconographical description mirrored or perhaps imitated the Index's contemporaneous understanding of photography, where the impartial and objective lens simply copied what was clearly there. Ideally, the iconographical 'reproduction' should be as good, or as objective, as the photographic reproduction, 'without interpretation'.

The other few sentences devoted to the photographs in Woodruff's Introduction form the following paragraph:

> The Index is also supplemented by a Monument File or collection of photographs of the objects and monuments described in the Subject File. The photographs are arranged by material and filed geographically by name of place rather than subject. It is a simple matter to turn from one file to the other and locate the corresponding pictures and descriptions. At the present time [1942] there are about 50,000

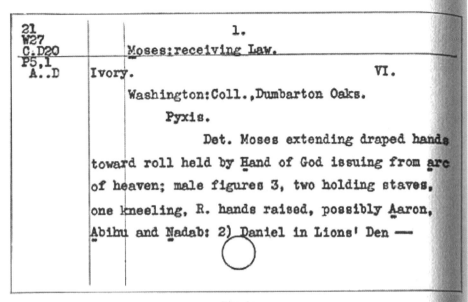

Fig. 1a

```
21
W27
C.D20        2.
P5,1    Moses:receiving Law.
A..D    Daniel wearing Phrygian cap, orant, flanked by
        towers 2 and by angels 2, each with R. hand on
        head of a lion: 3) Bel and the Dragon — statue
        of Bel,  staff in R. hand, mounted on column,
        dragon coiled about base: 4) eagle (below lock).

        Formerly in the Abbey of Moggio.
```

Fig. 1b

*Fig. 2. Text cards in Helen Woodruff,* The Index of Christian Art at Princeton University, *Princeton: Princeton University Press, 1942, p. 56. These two text cards, and two more on the next page in Woodruff's book, all refer to the frontispiece photograph.*[36]

photographs in the collection, and about 261,000 cards comprising the subject entries.[37]

Obviously, this section offers little or nothing in the way of hints of the existence of standards at the Index for 'good' or 'objective' photographs, nor very much in terms of how the photographs were made. However, one might find some reinforcement of the objectivity claim in the fact that it is supposed to be quite easy to shift from text to photographs and back to text. The disparity between the number of photographs versus subject cards also underlines the appeal of the efficiency of photography in recording and reproducing the same objects visually that subject cards do with language. Here the photographs are more efficient.

Woodruff's chapter on 'Technical Details' contains the only other section outside of the Introduction where she mentioned the photographs. Located under the key sub-title Monument File, we find four pages devoted to photography. One section defines the pictures as a group while referring to the book's frontispiece:

> The Monument File is a collection of photographs of the objects and monuments described in the Subject File. At the time that the description is written and recorded the best reproductions available are selected and [re-] photographed. The prints, made on 5 × 8 cards, are labelled and accessioned to correspond with the equivalent cards in the Subject File, including the subject-title of the master-card and the source of the reproduction.[38]

The first standard that she mentioned therein was that the reproductions *were* photographs. Apparently, this fact alone carried a heavy portion of the burden of objectivity. Photographs and photographic reproductions were considered more 'objective' than other kinds of representations. Moreover, Woodruff made no distinction between 'photographs of the objects and monuments' and photographs of 'the best [photographic] reproductions available'. Here we have something very close to the contemporary digital conception of photography where each copy or generation is not necessarily degraded in terms of quality or usefulness as compared with its original, not even a copy of a copy. That traditional photographs were assigned the same status at any time is quite remarkable.[39]

Evidence of at least one other standard appears in Woodruff's phrase 'best reproductions'. Perhaps we can deduce this standard, or these other standards, by examining the Index's process for making the photographs, since clearly the results of this process would be considered good or at least acceptable, otherwise the Monument File would not exist. Woodruff explained this technique only in general terms first:

> The process used by the Index for photographing reproductions from books or other prints does not produce uniformly good pictures, but an average high quality is maintained which is satisfactory for detection of details of iconography, and frequently adequate for a study of style. On the ground that any picture is better than none at all, many very inferior reproductions have to be used for photographing, but these are replaced as better reproductions are published.[40]

The appearance of the words 'good' and 'better' reinforces the assumption of the existence of standards. Index photographs, she claimed, must be 'satisfactory' for detection of details, and/or 'adequate' in terms of stylistic analyses. Thus, in addition

to the photographic standards and clarity already noted, perhaps the next most important standard is that the photographs must be consistent. While they may not be 'uniformly good' they must be of an 'average high quality'. The two key terms here are 'uniform' and 'average'. Indeed, the remaining standards seem to extend out of *consistency*.

One of these additional standards might be consistent *contrast*. Woodruff also mentioned that they were 5 × 8 inch prints; thus, we might add the standard of consistent *size*. The idea here, it seems, was that the prints should be large enough to allow for detection of details, but small enough to file easily and efficiently in one place. This balance, of course, is what makes the Index (and its burgeoning online resources) such valuable tools for scholars; it allows them to study a large amount of geographically dispersed material in a relatively short period of time with relative ease. Lastly, Woodruff mentioned that if any 'inferior reproductions' were to find their way into the Index, they would be 'replaced as better reproductions are published'. This adds a final standard that we might call, to use a current vocabulary, CQI, or *continuous quality improvement*.

Woodruff, unfortunately, did not go into the detailed specifics that iconographers crave about how such photographs were made to meet these standards. However, what she did say provides a sense of how the above theory of objectivity (photographic consistency, clarity etc.) was put into practice. Within her section on the Monument File, Woodruff described the procedures used by the Index from around 1930 to 1985:

> The apparatus for making the pictures was designed to do the work as rapidly and as inexpensively as possible. All exposures are made under identical conditions regardless of subject or state of the reproduction. Development of both film and prints is carried out on a time and temperature basis. Better results might be obtained in some cases were filters used, exposure times varied,[41] and different papers selected for the printing of different subjects, but the cost would become prohibitive. Since each picture is marked to show its source, easy reference can be made to the reproduction which was used for the Index picture.[42]

Curiously, Woodruff's passage here might be construed as admitting the existence of a law of diminishing returns in terms of objectivity and the standard of consistency. Woodruff recognised that 'better', perhaps even 'more objective', photographs might result from certain reproductions if the photographer were allowed to make different decisions about filtration, exposure time and paper grade to suit each specific image. It appears that cost was the limiting factor that prevented such a customised operation. However, allowing the photographer to make such decisions might also undercut the use-value of those images as 'objective' sources of information. As Cassidy explained: 'art historians operate with comparisons and contrasts'. How does this representation of the *Assumption* differ from that one? Can we detect patterns in the representational formulae, and so on? Thus, a scholar might feel more comfortable comparing two or more images made under identical conditions versus those made under conditions which the photographer felt would optimise whatever quality seemed to be the most important at that time, on a certain day, etc. In fact, I would suggest that the economic gains and benefits were only happy by-products of the search for objectivity or objective images.

Woodruff's final paragraph on the Monument File comes closest to describing precisely how all this was done. It turns out that a Princeton physics professor, H. L. Cooke, was called in to solve the Index's 'problems of photography'. Cooke designed a unique camera 'apparatus' and workflow for exposing and for printing the Index's photographs. His ideas and invention allowed for great 'speed of operation and reduction of cost'. Woodruff praised especially his 'ingenious platform for holding and manipulating the books so that no bindings need be injured or broken'.[43]

Unfortunately, around 1990 this one-of-a-kind contraption was dismantled and replaced with a contemporary copy stand. The current Senior Staff Photographer at the Index, John Blazejewski, operated 'the beast', as he calls it, for only a short time when he was first hired. However, several persons who used it on a daily basis still can be interviewed today.

## Conclusions

Several conclusions may be drawn from this analysis of photography and iconography at the Index of Christian Art. First, objectivity in large part was determined by harnessing available photographic technology and by the theoretical assumptions of the day about photography. Second, objectivity was achieved by reduction of differences: reduction of media, colour, dimension etc., to a 5 × 8 inch standard image. Third, fourth, and fifth, objectivity was clear, consistent, and economical. From these points one might further conclude that what was assumed for photography was expected from iconography, i.e. objectivity in these five senses. Therefore, contrary to Ragusa's argument that 'there was no model' for Morey's method of iconography, it seems possible that photography was the model for iconography at the Index.[44]

What about today's Index and the future? Has the early twentieth-century model based on Morey's view of photographic objectivity been replaced in the twenty-first century by the subjectivity and variability of digital images and the Internet? Are today's Index readers less sure of themselves when it comes to identifying the iconographical aspects of any particular image or work? It seems clear that the answer is yes. While the shift from objectivity to subjectivity in art photography and theory happened earlier, art historical methodologies probably change more slowly, and indeed correspond to changes in reproductive technologies, as from traditional to digital photography. Combining Morse and Morey's theories with McLuhan's famous phrase on the medium, perhaps the medium continues to be not only the message, but a model for the method of interpreting that message as well.

## Notes

I would like to thank Colum Hourihane, Director of the Index of Christian Art, and Professor Hal Foster of Princeton University for numerous insights and suggestions throughout the development of this paper. In addition, my sincere thanks go to Hazel Gardiner, Anna Bentkowska, and to the entire CHArt 2004 conference committee.

1   See, for example, Roberts, H. E. (ed.) (1995), *Art History through the Camera's Lens*, Langhorne, PA: Gordon and Breach. Robert's preface alone is subtitled 'Photographs! Photographs! In Our Work One Can Never Have Enough', p. ix.

2    See the newest 'oldest photograph' (one made by Nicephore Niepce) in the essay 'World's oldest photo sold to library', *BBC News* (Thursday, 21 March 2002). http://news.bbc.co.uk/1/hi/world/europe/1885093.stm (2 November 2005).

3    An undated letter from Morse to fellow painter Washington Alston as quoted in Staiti, P. (1989), *Samuel F. B. Morse*, Cambridge and New York: Cambridge University Press, pp. 226–28. Beaumont Newhall (1961) also cited this letter in his *The Daguerreotype in America*, New York: New York Graphic Society, p. 78.

4    Andrews, S. (1996), 'Academic Collecting at Princeton', *Medieval Art in America: Patterns of Collecting, 1800–1940*, University Park, PA: Palmer Museum of Art, Pennsylvania State University, p. 182. Allan Marquand, the first art historian at Princeton, taught his first course in the fall of 1882. The School of Art was founded on 18 June 1883.

5    http://ica.princeton.edu/range.html (31 October 2005).

6    http://ica.princeton.edu/range.html (31 October 2005). See also a similar description of the Index in an essay by former Director Brendan Cassidy (1993), 'Computers and Medieval Art: The Case of the Princeton Index', *Computers and the History of Art*, 4.1:3.

7    See Roelof van Straten (1993), 'What Is Iconography', in his *An Introduction to Iconography*, trans. Patricia de Man, Chemin de la Sallaz, Switzerland: Gordon and Breach, p. 3. Brendan Cassidy (1996), in his essay 'Iconography in Theory and Practice', *Visual Resources* 11: 3–4, p. 323, cites Jan Bialostocki's definition of iconography: 'the descriptive and classificatory study of images with the aim of understanding the direct or indirect meaning of the subject matter represented.'

8    http://ica.princeton.edu/range.html (2 November 2005).

9    *Iconography at the Index: Celebrating Eighty Years of the Index of Christian Art*, 28–29 October 1997.

10   By comparing the titles of the papers given on the first and second days, the first day dealt with the practical application of this Index-related method to specific art historical problems, whereas the second day focused on the theory behind the method itself. For example, Jaroslav Folda of the University of North Carolina gave the first presentation on day one entitled 'Problems in the Iconography of the Art of the Crusaders'. The next day, aside from the introduction and opening address, Lutz Heusinger of the Bildarchiv Foto Marburg gave the first presentation entitled 'How to Improve Art Historical Standards'.

11   Cassidy, B. (1993), 'Computers and Medieval Art: The Case of the Princeton Index', *Computers and the History of Art*, 4. 1, p. 3: 'our main concern is with iconography'.

12   Ragusa, I. (1998), 'Observations on the History of the Index: In Two Parts', *Visual Resources* 13:3–4, pp. 215–251, esp. 245. I would like to thank Colum Hourihane for this reference.

13   Morey, C. R. (1942), Foreword to *The Index of Christian Art at Princeton University*, by Helen Woodruff, Princeton: Princeton University Press, p. vii.

14   Andrews, S. (1996), 'Academic Collecting at Princeton', *Medieval Art in America: Patterns of Collecting, 1800–1940*, University Park, PA: Palmer Museum of Art, Pennsylvania State University, p. 183.

15   Andrews, S. (1996), 'Academic Collecting at Princeton', *Medieval Art in America: Patterns of Collecting, 1800–1940*, University Park, PA: Palmer Museum of Art, Pennsylvania State University, p. 183.

16   Andrews, S. (1996), 'Academic Collecting at Princeton', *Medieval Art in America: Patterns of Collecting, 1800–1940*, University Park, PA: Palmer Museum of Art, Pennsylvania State University, p. 183.

17   Morey, C. R. (1942), Foreword to *The Index of Christian Art at Princeton University*, by Helen Woodruff, Princeton: Princeton University Press, p. vii. What Morey meant by 'early' at this point was that the Index's scope had a limit of AD 700. This end date was soon extended to 1400, doubling the Index's scope.

18 Morey, C. R. (1942), Foreword to *The Index of Christian Art at Princeton University*, by Helen Woodruff, Princeton: Princeton University Press, p. viii. There are now four copies: Vatican Library; University of Utrecht, Holland; the Getty Center, Los Angeles; Dumbarton Oaks, Washington DC. See also Cassidy, p. 4.

19 Morey, C. R. (1942), Foreword to *The Index of Christian Art at Princeton University*, by Helen Woodruff, Princeton: Princeton University Press, p. ix.

20 Undoubtedly, cross-listing subjects and subjects would not work as well.

21 As far as I can tell, this bias corresponds to most of the literature on the Index. None of the publications that I have found to date focuses specifically on the use of photography in the Index in any sustained sense.

22 Ragusa, I. (1998), 'Observations on the History of the Index: In Two Parts', *Visual Resources* 13:3–4, p. 240. Ragusa reasserts this point on the same page: 'Again, unlike an encyclopedia article, [the Index] does not give a ready answer; it provides the material from which the researcher derives his own judgments.' She noted too that the Index is 'alphabetical throughout'.

23 Ragusa, I. (1998), 'Observations on the History of the Index: In Two Parts', *Visual Resources*, 13:3–4, p. 240.

24 Ragusa, I. (1998), 'Observations on the History of the Index: In Two Parts', *Visual Resources*, 13:3–4, p. 242.

25 Cassidy, B. (1993), 'Computers and Medieval Art: The Case of the Princeton Index', *Computers and the History of Art*, 4. 1, p. 9.

26 Cassidy, B. (1993), 'Computers and Medieval Art: The Case of the Princeton Index', *Computers and the History of Art*, 4. 1, p. 15.

27 See Baxandall, M. (1972), *Painting and Experience in Fifteenth-Century Italy: A Primer in the Social History of Pictorial Style*, Oxford and New York: Oxford University Press (2nd. ed. 1988).

28 Cassidy, B. (1993), 'Computers and Medieval Art: The Case of the Princeton Index', *Computers and the History of Art*, 4. 1, p. 15.

29 Cassidy, B. (1993), 'Computers and Medieval Art: The Case of the Princeton Index', *Computers and the History of Art*, 4. 1, p. 15.

30 Drewer, L. (1990), 'What Can be Learned from the Procedures of the Index of Christian Art', *The Index of Emblem Art Symposium*, Daly, P. M. (ed.), New York: AMS Press, pp. 121–38.

31 Drewer, L. (1990), 'What Can be Learned from the Procedures of the Index of Christian Art', *The Index of Emblem Art Symposium*, Daly, P. M. (ed.), New York: AMS Press, p. 122, my emphasis.

32 Drewer, L. (1990), 'What Can be Learned from the Procedures of the Index of Christian Art', *The Index of Emblem Art Symposium*, Daly, P. M. (ed.), New York: AMS Press, p. 125.

33 Drewer, L. (1990), 'What Can be Learned from the Procedures of the Index of Christian Art', *The Index of Emblem Art Symposium*, Daly, P. M. (ed.), New York: AMS Press, p. 121.

34 Woodruff, H. (1942), *The Index of Christian Art at Princeton University*, Princeton: Princeton University Press, p. v. The number of pages behind each heading confirms this point: Foreword, pp. vii–ix (3 pages); Introduction, pp. 1–10 (10 pages); Subjects of the Index, pp. 11–53 (43 pages); Technical Details, pp. 54–74 (21 pages); Sample Description, pp. 75–79 (5 pages); and Chart, pp. 80–83 (4 pages). Thus, the subject cards receive the greatest amount of coverage in the book while the objects cards or photographs do not even appear on the table of contents.

35 Woodruff, H. (1942), *The Index of Christian Art at Princeton University*, Princeton: Princeton University Press, p. 3, my emphasis.

36  Four total subject cards appear in Woodruff, pp. 56–57. The two not reproduced here show the Index's bibliography for the object in the frontispiece image. An additional six text cards on various other objects appear in Woodruff, pp. 76–79.

37  Woodruff, H. (1942), *The Index of Christian Art at Princeton University*, Princeton: Princeton University Press, p. 9.

38  Woodruff, H. (1942), *The Index of Christian Art at Princeton University*, Princeton: Princeton University Press, p. 71–72.

39  For a related discussion of photographic reproductions in the so-called Museum Without Walls, see my essay on 'Malraux's Photography', *History of Photography*, 26: 4 (winter 2002), pp. 269–275. In a certain way, digital photography is thus both more and less objective than traditional photography. It is more objective in the sense that it is possible to maintain near complete consistency among all copies, and less objective in the way that it is 'so easy' to manipulate the original and/or the copies and increasingly difficult to detect that manipulation.

40  Woodruff, H. (1942), *The Index of Christian Art at Princeton University*, Princeton: Princeton University Press, p. 73.

41  They did in fact vary somewhat according to John Blazejewski, current Index Senior Staff Photographer. Interview with John Blazejewski, November 1997.

42  Woodruff, H. (1942), *The Index of Christian Art at Princeton University*, Princeton: Princeton University Press, p. 73. Rosalie B. Green, Director of the Index from 1951 to 1981, who also used this apparatus, explained that this practice started long before the invention of the Xerox machine or any other similar technology. Thus, the emphasis on economy over quality was in large part a factor of the immense amount of material that needed to be copied and the lack of any contemporary means to duplicate it. It would be interesting to see what system the Index would chose today if it were to start all over from scratch, both on the paper Index and the electronic one. Phone interview, 19 January 1998.

43  Woodruff, H. (1942), *The Index of Christian Art at Princeton University*, Princeton: Princeton University Press, p. 74. Woodruff concluded: 'We wish to take this opportunity to express our appreciation to Professor Cooke for the time and effort he has contributed to the solution of the Index problems of photography'.

44  In that sense, the iconographic equalled the textual and the photographic. My future research into the issues discussed in this paper will investigate the degree to which Morey may have also modelled his ideas on the Bibliotheque Ducet, an archive of photographs he visited prior to founding the Index. For this, see Hourihane, C. (ed.) (2002), *Insights and Interpretations: Studies in Celebration of the Eighty-fifth Anniversary of the Index of Christian Art*, Princeton: Princeton University Press. I would like to thank Colum Hourihane for this information and reference.

## Further Reading

Barthes, R. (1961), 'The Photographic Message', in Heath, R., ed. and trans., *Image, Music, Text*, New York: Noonday, 1977, pp. 19f.

Bunnell, P. ed. (1980), *A Photographic Vision: Pictorial Photography, 1889–1923*, Salt Lake City, UT: Peregrine Smith. See the following reprinted essays: Hartmann, S. [1904], *Plea for Straight Photography*; Stieglitz, A. [1899], 'Pictorial Photography' and Demachy, R. [1907], 'On the Straight Print'.

Clarke G. (1997), 'What is a Photograph?' *The Photograph*, Oxford: Oxford University Press, pp. 11–25.

Crimp, D. (1980), 'On the Museum's Ruins', *October*, 13 (summer), pp. 41–57.

Eastlake, E. (1857), *Photography*. Repr. in Newhall, B., ed., *Photography: Essays & Images*, New York: MOMA, 1980, pp. 81–95.

Emerson, P. H. (1889), *Science and Art*, Repr. in Bunnell, P., ed., *A Photographic Vision: Pictorial Photography, 1889–1923*, Salt Lake City, UT: Peregrine Smith, 1980, pp. 81–94.

Hershberger, A. E. (2002), 'Malraux's Photography', *History of Photography*, 26, 4 (winter), pp. 269–275.

Hershberger, A. E. (forthcoming 2006), 'Krauss's Foucault and the Foundations of Postmodern History of Photography', *History of Photography*.

Krauss, R. (1982), 'Photography's Discursive Spaces: Landscape/View', *Art Journal*, 42: 4 (winter), pp. 311–319.

Paul Strand, 'Photography' (1917), in *Classic Essays on Photography*, ed. Alan Trachtenberg (New Haven, CT: Leete's Island Books, 1980), 141–142.

# The Good, the Bad and the Accessible: Thirty Years of Using New Technologies in BIAD Archives

Sian Everitt

This paper reflects upon the use of technologies in BIAD Archives over the past 30 years. It traces attempts to use technology to improve the accessibility of the collections from the original automated access system of 1972 through numerous database projects to twenty-first century online endeavours. The paper considers the successes and the disappointments of 30 years of initiative and collaboration. It comments on the lessons learned in trying to harness the potential of computers to manage and interpret diverse collections in art and design.

## BIAD Archives

Before discussing the use of technology to access the collections, it is worthwhile outlining their nature and diversity. BIAD Archives holds the archives and collections of the Birmingham Institute of Art & Design (BIAD), a faculty of the University of Central England (UCE). BIAD Archives is a specialist repository that holds over twenty separate archives and collections, covering the fields of art and design education, museology and public art. The collections range in size from under 50 to over 40,000 items and include paper documents and books as well as artworks, photographs and artefacts.

Our main institutional collection is the BIAD School of Art Archive that documents the history of the institution from its foundation in 1843 as a Government School of Design until its absorption into what was then known as Birmingham Polytechnic in 1970. Although historically titled the School of Art Archive, this is something of a misnomer as it is a mixed collection of archival papers, and staff and student artworks. In fact, there are over 3,500 artworks and designs on paper by more than 700 former staff and students. There are more than 2,000 photographs and lantern slides of works and classes. There are also minute books, student registers and record cards, administrative files and artefacts.

BIAD Archives also hold donated collections documenting pedagogical initiatives in the teaching of art and design in schools, perhaps the most significant of which is the Marion Richardson Archive. Marion Richardson (1892–1946) trained as an art teacher at Birmingham College of Art and Design from 1908 to 1912. She went on to be an influential child-centred art education practitioner in the first half of the twentieth century, believing that all children had aesthetic capabilities if only they were encouraged in appropriate ways. She advocated the use of the memory and visual imagination rather than technical exercises and she also developed a pattern-based method of teaching handwriting. The archive contains correspondence,

diaries, unpublished papers and lectures, glass slides, photographs, part of her art library, and several thousand examples of children's artworks.

The most recent donation to BIAD Archives was the Public Arts Commissions Agency (PACA) Archive in 1999. PACA was formed in 1987 and handled mainly large-scale, mainstream public art projects throughout the UK. PACA was a company and registered charity with offices in Birmingham and, later, London. The PACA Archive is a business archive. It contains a lot of typical archival materials – correspondence, contractual and financial information, trustees' papers and committee minutes. Also, given the nature of the business, there are artists' proposals, sketches, drawings and architectural plans. There is an extensive slide and photographic record of the public art projects PACA managed and a collection of books, journals, exhibition catalogues and trade magazines comprising the company library.

In outlining just three collections, their diversity and richness is revealed. BIAD Archives is a relatively small-scale repository with specialist research collections held in an academic context. This academic context is important and potentially problematic. As part of the University of Central England (UCE), the institutional mission statement governs BIAD Archives. This has a strong emphasis on service to the wider community and Lifelong Learning, with the University as a whole aiming to 'develop the social infrastructure and improve quality of life in the region'.[1] Marta Lourenco has noted that 'traditionally, university museums have pursued a triple mission: research, teaching and public display'.[2] The position of BIAD Archives is not dissimilar, with competing expectations of research outcomes, reintegration with teaching and public access.

It was the donation of the PACA Archive that prompted BIAD to reassess its archival holdings and collections management. There had not been a member of staff dedicated to BIAD Archives for a number of years and the archives had been effectively closed for over 20 years. Significantly, there was no substantive intellectual control of the Faculty's collections as none were catalogued. Indeed, a survey in 2000 on behalf of the West Midlands Regional Museums Council and East Midlands Museum Service recommended that BIAD should be treated as one of four priorities in the region as the collections were 'virtually without any useable documentation'.[3] BIAD may have been an extreme case: however, we were not an isolated one but more symptomatic of a general malaise. The late 1990s saw many surveys of archives and special collections in Higher Education Institutions (HEIs), including the 1997 JISC *Study of the Archival Records of British Universities*, Kelly's *The Management of Higher Education Museums, Galleries and Collections in the UK* and the Society of Archivists' ongoing *Missing Link* project.[4] These regional and national surveys highlighted a need to improve the management of the majority of HEI archives and collections.

At BIAD, this need was addressed when a full-time post and the new management body, the BIAD Archives Steering Group, were established in 2000. The Archive Development Project was initiated in recognition of the fact that prioritising the establishment of intellectual control of the collections – discovering and documenting the what, where and why – would create a solid foundation for future developments.

Despite the seemingly lengthy period of inaction, the Archive Development Project has been built on past experience and BIAD's history of aspiration in using innovative technology to facilitate access to and interpret the collections.

## Databases

The original automated access system to the collections was developed between 1972 and 1974, and is now fondly remembered as the 'Jiggling Box'. Developed by the School of Art Education with funding from the Leverhulme Trust, this was a system for mechanically-aided retrieval via edge-notched cards which held microfiche records of the resources. Admittedly, this was not an application involving digital technology. It was not even the development of new technology – the history of punched cards as an indexing system goes back to 1886.[5] The significance of the project is in its recognition of the nature and diversity of archival materials in art education and the inappropriateness of a library approach to indexing and access. The need identified was for flexible indexing and machine-aided searching given the quantity of the resources. A complex system of pyramid coding around all four edges of the cards was developed. The cards were placed in a machine and knitting needle-like rods inserted into pre-coded slots. Then the machine would vibrate the cards in order to separate out those that had been punched in the relevant position, hence the nickname. Whilst several thousand of the notched cards have survived, the machine has not.

BIAD was an ambitious early innovator in recognising the potential of computer technology. In 1975, under the auspices of a Social Science Research Council grant, full-scale digitisation was considered for the Marion Richardson Archive. The project team in the School of Art Education suggested that 'the entire archive should be transcribed onto a computer's magnetic disks'.[6] Having explored the idea with the Computer Centre, they concluded, 'Although this was found to be technically feasible, the cost of carrying out this work was quite prohibitive and the idea was abandoned'[7] – an early example of arguably the biggest problem still faced by digitisation projects.

Undeterred, BIAD continue to imagine the potential of computer technology for archival resources. As early as 1981, BIAD was developing what was in effect an online and interactive catalogue. The Art Education Computerised Information Retrieval System (AECIRS) had grown out of the earlier edge-notched card system. The card system had quickly proved unreliable due to frequent notch failures with the result that 'selecting a section of useful information became an exercise in futility and mounting frustration'.[8]

The claim to have developed AECIRS as an online system as early as 1981 is neither minor nor insignificant. It is however, difficult to ascertain whether the AECIRS system was good, bad or accessible: it is rather best evaluated as the invisible. It was only during the course of the research for this paper that I came across mention of AECIRS. The system itself does not survive and it is doubtful that practice followed the aspiration; AECIRS only survives through documentation, in this case a single Master's dissertation in UCE's library.[9] From this dissertation a description of the system and an understanding of the objectives of its designers can be

gleaned. The vision was that in all schools in Birmingham 'the art room would have access to a micro-computer with a teletype terminal linked by telephone (acoustic coupler) to a large mainframe computer in the Polytechnic'.[10] The mainframe computer would hold a database of the archives and resources in the School of Art Education. Teachers would also be able to add records of the resources in their own schools as well as recording the results of their searches as topic lists and resources in their own right. In effect, it appears to have been designed as an interactive and user-determined indexing system.

The innovative nature of the project's aspirations is highlighted in the results of the questionnaire sent to all local art teachers during the design of the system. It seems almost unbelievable now that the first question was 'Have you ever seen a computer working?' and that 21 per cent of the responses were negative.[11] Another reminder of the innovative nature of the project in 1981 is that 74 per cent of the teachers who replied did not know the meaning of the term 'floppy disk'.[12] Although the School of Art Education created and used AECIRS, there is no evidence that the anticipated online access for local schools was implemented. AECIRS is thus an example of a future past, an exciting aspiration to harness the unique features of computer technology directly to inform and assist the teaching of art and design.

Only six years after AECIRS was mooted, another attempt was made to create computerised indexes to BIAD's archival material. This was an internally-funded project resulting from a structural reorganisation of the Faculty and physical moves to unify the collections. Interestingly, the specification report[13] produced does not appear to have drawn on AECIRS at all, suggesting that the system had already fallen into disuse.

In 1987 a catalogue of one of the collections, the School of Art Archive, was created as a database. The software used was STRIX (from the Latin for strident owl and its association with knowledge and learning). Unlike the earlier AECIRS, which used a large Macintosh, the database created in 1987 ran under PC and MS-DOS. Again, this system, although more limited in scope, seems to have fallen out of use relatively quickly. By 2000, when the current Archive Development Project was initiated, only part of the system survived – parts of the original IBM, a floppy disk labelled 'back up' and reams of printouts. Whilst the existence of the printouts demonstrated quite clearly that the system had been used, the printouts themselves were difficult to decipher. No recognisable cataloguing standards had been used, and the field names (and in some fields the data itself) were recorded as a series of abbreviations and codes. The key to these codes has not survived, unfortunately, and as a prime example of the importance of digital preservation, both the IBM's hard drive and the back-up files on the floppy were too corrupted to retrieve any meaningful data.

## Into the Twenty-First Century

Despite BIAD's early recognition of the potential of computer technologies, when the BIAD Archive Development Project was initiated in 2000, we were in the frustrating position of having to start again. Both within BIAD and the parent institution, UCE, there is a great wealth of experience in developing ICT products. BIAD includes a multidisciplinary research team – Digital Design User Lab – which has

expertise in usability, psychology, human-computer interaction, digital media design and software engineering. However, whilst UCE and BIAD are at the cutting edge of digital design, BIAD Archives were not even meeting the most basic of collection management standards.

The Archive Development Project was created to raise awareness and recognition of the potential of the collections both within the university and for the wider community. Yet with no extant catalogues (paper or digital) this had to be achieved without creating premature and unrealistic expectations in users of BIAD Archives. BIAD's past experience led to concerns over the scale and sustainability of investment in catalogue databases. We were also aware of wider concerns in the sector of the benefits of simply putting a collections database online. For example, Zorich has argued that although a collections database is an invaluable staff tool it does 'not convey information in a format that satisfies general audiences'.[14] Cameron has pointed out in respect of online museums that a search interface to a collections database is of little use to a non-specialist user, someone who lacks prior knowledge of the information and is unaware of the terminology used or how the data is modelled.[15] Thus, despite the in-house expertise and in recognition of the limited intellectual control of the collections, the decision was taken not to prioritise putting the collections online. It must be stressed, however, that this was a strategic decision and that the Archive Development Project is seen as an incremental process.

As I have shown, BIAD's collections contain a rich and diverse body of materials including bibliographic and photographic materials, paper records, artworks and artefacts. Yet research into appropriate cataloguing standards quickly revealed that the collections' diversity presented a challenge as there was no cross-domain standardisation of collection documentation, nor at that time any commercial software system that covered all three domains – museums, archives and libraries. Furthermore, the three domains take different approaches and use differing terminology. The national governing body, Resource (now MLA Council), noted that there were 'no common terms and concepts associated with collections management' and expressed 'the aim of establishing a common set of terms, or at least an understanding of the different ways in which terms are used'.[16]

The challenge has been to achieve a balance, negotiating a path between the differing approaches to cataloguing collections whilst recognizing that those differences reflect distinctive attributes of each type of material. We wished to create an integrated catalogue for each collection rather than creating separate but related catalogues of each collection's archival and artefact materials. Whilst there is no single cataloguing standard appropriate to the diversity of materials, we decided to utilise recognised standards to whatever extent possible for cataloguing structures and authority files. This would go some way toward ensuring the consistency of data within the catalogue databases and in relation to other collections nationwide. The use of recognisable standards should also aid future preservation of the data.

It was decided to adopt an incremental approach. Rather than trying to develop a full collection management system (CMS) at the outset, BIAD decided to concentrate on a more limited descriptive catalogue database. The concentration on the

descriptive element of cataloguing, rather than full procedural documentation, allowed space for an iterative design process whereby the experience gained during the cataloguing process has informed the development and revision of the catalogue database structure. It was also a pragmatic limitation, presenting less risk than building a whole CMS around an untested catalogue structure. A full examination of BIAD's innovative approach to cataloguing is beyond the remit of this paper. In summary, the approach has been to use an overall catalogue structure based on the archival standard ISAD(g).[17] Additional fields are available at the Item level of the catalogue structure relevant to the nature of the object and consistent with SPECTRUM and AACR2.[18] This creates a multi-level catalogue with integrated collection-level descriptions and preserves the contextual information vital to the authenticity and significance of the materials.

A Microsoft Access database is being used to test the structure and as a tool for staff whilst cataloguing. In an attempt to future-proof the catalogues and having learnt the lessons from AECIRS and the STRIX project, it has been accompanied by full technical and procedural documentation. The use of this standard database package enables interoperability with central UCE systems and support from the Faculty's IT staff. It will also ease data migration for both future developments and digital preservation.

This is not to say that BIAD Archives has ignored either the Internet, or the skills and experience available within BIAD. Like almost every other archive and museum, we have published a website, which was designed and created by Digital Design UserLab. This website has not been a static development, and it benefits from continuing support and development by UserLab. It has recently been redesigned to be a purely CSS- (Cascading Style Sheet) driven site as one of the first steps towards improving accessibility. The site, along with others produced by UserLab, is moving towards Priority 2 (Level AA) of Web Content Accessibility Guidelines (WCAG).[19] Their aim is to achieve Priority 3 (Level AAA) within six months.

Whilst UserLab manages the structure and design of the site, BIAD Archives staff can easily and quickly update the content using the Macromedia Contribute program. The content of the website has been purposely limited. We are unashamed to say that, in its current guise, it is purely a marketing tool and not a learning resource. The content includes the nuts and bolts of how to use BIAD Archives along with descriptions of some of our collections. This limitation is strategic, not only in terms of managing user expectations, but also in terms of managing internal resources and achieving a balance between technological development and basic, yet essential, manual collection management activities. In terms of achieving its limited objectives, the website has been a success.

## Strategic Collaborations

Alongside using technology as a tool in the production of detailed in-house catalogues, BIAD recognised the value of collection-level descriptions (CLDs). Initially, brief descriptions were created as part of an audit of the Faculty's holdings in 2000. It was soon recognised that such collection-level descriptions could also play a role in the wider dissemination strategy, particularly given the decision not to immediately

pursue online access and digitisation. On the summary level of a collection-level description, it is easier to achieve consistency and compatibility with the various domain-specific standards used within Web portals. Indeed, the existing descriptions have been manipulated to produce multiple versions for submission to multiple portals with relative ease. We have submitted descriptions to the HE Archives Hub and to the NRA (National Register of Archives) and ARCHON (the online database of repositories), both at the National Archives, as well as publishing them on our website. With relatively small resource implications, we have been able to significantly raise the profile of BIAD Archives and hopefully with an increase in awareness, achieve an increase in accessibility.

A strategic approach has also been taken to utilising collaborative regional and national digital initiatives to increase access to BIAD Archives. Whilst we have the ambition, the ideas and an awareness of the potential of technology, we are also aware of the history of aborted or neglected projects. BIAD Archives is a relatively small-scale operation with only 1.8 staff and we do not have the resources to undertake large ambitious ICT-based projects. As well as the pragmatic rationale for collaboration as a strategy, association with larger consortia of regional and national institutions raises our profile. Collaboration also helps to legitimise our collections, providing external recognition of their significance.

One example of the benefits of collaboration is our experience of AHDS Visual Arts Fine Art Project. Launched as fineart.ac.uk, the project created a website resource 'that celebrates the history and achievement of the artist practitioner in UK art education'.[20] The pilot resource delivers online around 200 digital images and associated catalogue records and metadata made up from work selected from HEIs, along with the full digitisation of the Council of National Art Awards Trust Art Collection. In creating the pilot resource, AHDS Visual Arts' aim was to establish a model, and 'to define best practices (by scale, circumstance and technical complexities of existing physical collections) for the digitisation and delivery'[21] of a distributed or virtual national collection. BIAD were one of the ten participating institutions. We were funded to digitise a small sample, just fifteen works from the BIAD School of Art Archive, and provided with templates for catalogue records and image metadata, and guidance on copyright clearance.

As well as the obvious benefit in raising the profile of BIAD and its collections through participation in a national project with prestigious partners, this collaboration has directly benefited our strategic planning process. It was a very useful experience for BIAD Archives, allowing us to test workflows and procedures for digitisation and the resource implications. The guidance on copyright procedures and direct experience of the research and complications involved was particularly beneficial. We were asked to provide specific images and data, reflecting the Arts and Crafts period of the School. It is thus not perhaps a true reflection of the diversity of the collection, nor of the activities of Birmingham School of Art. The pilot resource created is attractive, if a little basic in being primarily a collection database. Some interpretative elements have been developed by AHDS Visual Arts – taking the form of essays rather than interactive applications of technology. The experience has undoubtedly benefited BIAD Archives and AHDS Visual Arts have achieved their objectives in establishing a model and defining best practice. However, to date, the

project remains a pilot and without further funding cannot be expanded to complete the resource.

## Conclusions

BIAD's use of technology in relation to its archives and collections has a chequered history, and this paper has considered the successes and the disappointments of 30 years of initiative and collaboration. A number of conclusions can be drawn from the lessons learnt in trying to harness the potential of computers to manage and interpret diverse collections in Higher Education.

There have undoubtedly been successes. BIAD quickly recognised the potential of computer technology with plans for full-scale digitisation of an archive as early as 1975. In 1981, BIAD attempted with AECIRS to create an online interactive collections database with integrated teaching resources for schools. These early initiatives also demonstrate some of the problems BIAD has experienced in exploiting technology for its collections. The historical difficulties of inadequate resources for technically-feasible projects, sustainability and digital preservation retain a currency and relevance for twenty-first century initiatives.

BIAD has also demonstrated persistence, repeatedly attempting to unite technology and archives in art and design. The BIAD Archives Development Project has learnt from these previous projects and taken a strategic, collaborative and incremental approach. Admittedly, the Microsoft Access database and website are more limited in scope than the earlier big ideas; however, they are sustainable and successful in achieving the objectives set for them. We have not lost sight of the potential of computer technology as a tool in the management, interpretation and accessibility of BIAD Archives, Perhaps, it is rather the recognition that however exciting the potential, technology is one just tool amongst many. The incremental approach to integrating technologies in collection management, establishing intellectual control and raising the profile of BIAD Archives, it is rather has provided the foundations. The challenge for the future is to build upon these foundations.

## Notes

1    UCE (1999), *The Educational Character and Mission of the University*, http://www.fia.uce.ac.uk/ fiagov.htm (active 2 November 2005).

2    Interviewed in Mulhearn, D. (2003), 'University Challenge', *Museums Journal*, 104: 5, October, p. 32.

3    Arnold-Foster, K. and Weeks, J. (2000), *Totems and Trifles: Museums and Collections of Higher Education Institutions in the Midlands*, Bromsgrove: West Midlands Regional Museums Council, pp. 19 and 28.

4    Parker, E. and Smith C. (1997), *Study of the Archival Records of British Universities: a report for the Joint Information Systems Committee*, London: JISC; Kelly, M. (1999), *The Management of Higher Education Museums, Galleries and Collections in the UK*, Bath: University of Bath; The Society of Archivists *Missing Link* project, http://www.archives.org.uk/resources/missinglinkfinal.pdf (active 2 November 2005).

5    In 1896, Henry P. Stamford developed the first edge-notched card; see Williams, R. V., 'The Use of Punched Cards in US Libraries and Documentation Centers 1936–1972 – (web extra) Punched Cards a Brief Tutorial', *IEE Annals of the History of Computing*, http://www.computer.org/annals/ punchedcards.htm (active 2 November 2005).

6  Campbell, A. D. (1977), *S.S.R.C. Marion Richardson Project Final Report*, unpublished report, City of Birmingham Polytechnic, p. 16.

7  Campbell, A. D. (1977), *S.S.R.C. Marion Richardson Project Final Report*, unpublished report, City of Birmingham Polytechnic, p. 17.

8  Steveni, D. (1983), *A Computerised Information Retrieval System in Art Education*, unpublished MA Dissertation, City of Birmingham Polytechnic, p. 28.

9  Steveni, D. (1983), *A Computerised Information Retrieval System in Art Education*, unpublished MA Dissertation, City of Birmingham Polytechnic, p. 28.

10  Steveni, D. (1983), *A Computerised Information Retrieval System in Art Education*, unpublished MA Dissertation, City of Birmingham Polytechnic, p. 67.

11  Steveni, D. (1983), *A Computerised Information Retrieval System in Art Education*, unpublished MA Dissertation, City of Birmingham Polytechnic, p. 105.

12  Steveni, D. (1983), *A Computerised Information Retrieval System in Art Education*, unpublished MA Dissertation, City of Birmingham Polytechnic, p. 105.

13  Swift, J. and Slater-Dickens, J. (1987), *The Design of Archival Indexing and Retrieval Systems and their Applicability to the Birmingham School of Art Archive*, unpublished report, City of Birmingham Polytechnic.

14  Zorich, D. M. (1997), 'Beyond Bitslag: Integrating Museum Resources and the Internet', *The Wired Museum*, Jones-Gormil, K. (ed.), Washington DC: American Association of Museums, p. 187.

15  Cameron, F. (2001), 'World of Museums, Wired Collections – the Next Generation', *Museum Management and Curatorship*, 19:3, p. 309.

16  Resource (2002), *Preserving the Past for the Future*, http://www.mla.gov.uk/action/stewardship/preserv01.asp (active 28 October 2004).

17  International Council on Archives (2000), *General International Standard Archival Description (ISAD(g))*, http://www.icacds.org.uk/eng/standards.htm (active 2 November 2005).

18  Cowton, J. and Grant, A. (eds) (1997), *SPECTURM: The UK Museums Documentation Standard*, Cambridge: the Museum Documentation Association; Anglo American Cataloguing Rules (1998), see Gorman, M., *The Concise AACR2 1998 edition*; second revised edition (AACR2) 1999, London Library Association.

19  The WCAG have been developed by the World Wide Web Consortium (W3C)'s Web Accessibility Initiative (WAI) and published at http://www.w3.org/TR/1999/WAI-WEBCONTENT-19990505 (active 2 November 2005).

20  http://www.fineart.ac.uk (2 November 2005).

21  AHDS Visual Arts, *The National Fine Art Education Digital Collection Feasibility Study*, http://vads.ahds.uk/fineart/feasibility.html (active 2 November 2005).

# Object Information at the Victoria and Albert Museum: Successes and Failures in Web Delivery

Melanie Rowntree

With the V&A's first database-driven, object information interface on the Web entering its second year of delivery, this paper reviews the Museum's history of presenting collections data online. Looking at four projects, namely *Images Online, British Galleries Online, Exploring Photography* and *Access to Images*, this paper discusses their aims, planning and content creation. The successes and failures within each project and the potential for re-purposing data are also considered.

## Images Online

### Aims

*Images Online* was the V&A's first attempt at Web delivery of its collections data, featuring over 1,500 objects and images. The development of this Web resource falls into two phases. The first phase of the project was instigated by V&A senior management who perceived a need for images of the collections to be accessible via the Museum's website. Senior management staff who drove the project were keen to make this happen within a matter of months. One of the main aims of the first phase was to have *Images Online* ready for the launch of the new V&A website in late 1999. The aim of the second phase was to re-package the same content as part of another new V&A site designed in-house in 2001.

*Images Online* focused on image delivery rather than textual content. The project primarily aimed to deliver basic object information, such as the place, date and artist/maker attribution for over 1,500 of the important objects in the collection.

### Deliverables

There is little documentation available on the development of the *Images Online* Web interface. The specifications from Oyster Partners, who designed the 1999 V&A website, show an intention to search by category and not to provide free text searching (fig. 1).

It is possible that the screenshot in fig. 1 is the final specification for the webpage. This, however, cannot be verified because the archived pages from the 1999–2000 Oyster-designed V&A website are inaccessible. *Images Online* is unavailable on all Web archiving pages. In-house archiving of the V&A website had not been instigated at that time.

By phase 2 of *Images Online*, free text searching and browsing were available (fig. 2). It is unclear whether free text searching was added to the specification illustrated

Welcome to V&A Images. This area allows you to search through almost 2000 images, a small part of the V&A collection. You can search using the drop-down menus to the left, or browse using the links below. Your results will be displayed as thumbnail images which can be enlarged by clicking on the image of your choice.

**V&A**

**Search**

Define your search using the options below. Your results will be displayed chronologically, or you may use the "Sort" menu to choose to display your results in alphabetical order (ie alphabetically by country etc). Finally, click 'Go' to submit your search

Country:

| Any ▾ |

Century

| Any ▾ |

Associated Name

| Any ▾ |

Type

| Any ▾ |

Sort by

| Century ▾ |

| Go | | Reset |

**Browsing Facility**

Browse our collections by clicking one of the categories below:

15th Century Manuscripts
16th Century English Paintings
16th Century Indian Paintings
18th Century British Furniture
18th Century Textiles
19th Century British Photography
19th Century English Paintings
19th Century Glass
20th Century British Fashion
20th Century Glass
20th Century Jewellery
American objects in the V&A
Aubrey Beardsley
Chinese Ceramics
English Silverware
Indian Sculpture
Italian Sculpture
Japanese Prints
William Morris

*Fig. 1. Specification from Oyster Partners for the* Images Online *interface.*

in fig. 1 and delivered in the first phase, or added to the redesigned search screen in phase 2. In both phases, users were able to search by associated place, a timeline or by classification. It is unclear, however, whether the 'Associated Name' field was present in the initial interface and removed in phase 2. It is possible that the relevant field was not populated with sufficient data to justify this search.

### Planning and Content Creation

*Images Online* was first delivered on the Web in 1999, yet it is now virtually impossible to find any evidence of project planning, and little information is available on the project overall. It is possible that formal content creation plans never existed.

Content creation began with a set of primary images being chosen by curators from the Photo Catalogue (the V&A image database). This system was used as the source

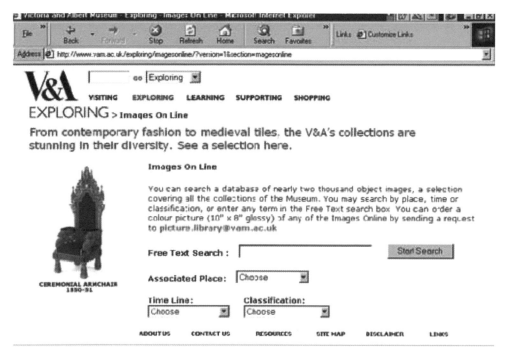

*Fig. 2.* Images Online *interface from V&A website launched in 2001.*

because the necessary image content was not yet available from the Museum's Collections Information System (CIS, based on the MUSIMS database from System Simulation Ltd). CIS had been the primary repository for textual object information since 1998. By 1999 the system had just entered phase 2 of its four-phase development. At that time it held little electronic content, included no images and was not yet capable of delivering object information to the Web. Textual object data in CIS was scant when *Images Online* was proposed. This left senior management with the choice either to wait several years for completion of CIS phases 3 and 4 and the subsequent creation of 1,500 catalogue records, or to look elsewhere for object data. They decided to take the object data from the Photo Catalogue, which contains brief and unfortunately unauthoritative object information associated with images of the objects.

In the initial stages of the development of images online, object data was exported from the Photo Catalogue into a Microsoft Excel spreadsheet. As the object information in the Photo Catalogue was not authoritative, it was important that the spreadsheet be checked and, if necessary, corrected by curators to ensure its accuracy. The whole project took two to three months and was, during that time, a priority for curatorial staff. The impending deadline reduced the amount of time curators were given to check the accuracy of the 1,500 object entries to between just four and six weeks. Although many amendments were made to the data, some errors remained at the time curators were told to hand back the content for loading. Consequently when the site went live and errors were apparent, curators felt uneasy about claiming ownership of the information.

In terms of the technical delivery of the site for phase 1, the data from the MS Excel spreadsheet was migrated into a small MySQL database application, from which the data could be accessed via the website.

No content was planned or created for phase 2 of the project. As stated, data was re-presented through an interface designed by a new Web development team (employed after the original team left in 2000).

### Issues

In phase 1 there were a number of issues which negatively affected the outcome of the project. First, the lack of project planning led to the presentation of inaccurate data. Second, technical problems with the Oyster V&A website launched in 1999 meant that data was essentially locked into the website once loaded. Third, *Images Online* was powered by the Media Surface Content Management System, which did not run the searches very effectively, leading to the delivery of unexpected result sets.

In phase 2 the new Web development team had no site documentation and were left with the task of unpicking a piece of software of which they had no experience. While preparing for the launch of the new website in November 2001, the Web development team rebuilt the navigation for V&A website. They managed to export and then re-import the *Images Online* data and clean up some of the problems, such as images attached to the wrong objects and obviously incorrect data. At this stage the new Web development team were working towards a very tight deadline for the launch of the new website in November 2001. No assistance was available from curatorial staff who were committed to delivering the British Galleries re-display and material for the *British Galleries Online* interactive display.

### Conclusions

Looking back on the project it now seems clear that although putting object information on the Web was an important step for the V&A, the lack of time and resources allowed for content creation negatively affected the success of the project. Senior management placed the delivery of the Web material as their priority and for this reason, did not allow time for planning how the project would be achieved. Data consistency was undermined by the decision to reuse existing but unreliable object data without either allotting time for a thorough clean-up or using terminology controls. *Images Online* was locked into the V&A website as static webpages, thus restricting any data re-purposing. Before *Images Online* was removed from the V&A website to make way for a new object information and image delivery site, documentation staff were forced to re-key the information from an MS Excel spreadsheet of material into CIS in order to save any valuable data. These implications were not anticipated when planning the content creation.

## British Galleries Online (BGO)
### Aims

The British Galleries project was a seven-year gallery refurbishment programme encompassing more than 15 rooms over two floors of the V&A. The project generated

about 200 high-tech, low-tech and no-tech interactive gallery displays including 18 Web-based interpretative applications served to 40 kiosks.[1] *British Galleries Online* (*BGO*) was the largest and most complex of the gallery interactives. The main aim of the *BGO* was to provide detailed object information and broader contextual information for every object in the British Galleries. The BG project team intended to provide a personal, educational experience through *BGO*, encouraging visitors to engage in an exploratory relationship with the objects in the collection. The *BGO* was scheduled to be delivered simultaneously in the gallery study rooms and on the new V&A website in November 2001.

### Deliverables

The project team wanted to deliver a database of 3,000 objects containing additional contextual information such as biographies, object type and place descriptions. *British Galleries Online* would allow the visitor to approach objects via associated text on either the four main gallery themes: 'style', 'who led taste', 'fashionable living' and 'what was new', or four additional themes: 'timeline', 'place', 'people' and 'types of object' (fig. 3). Linked text and a selection of stories about how objects were used in

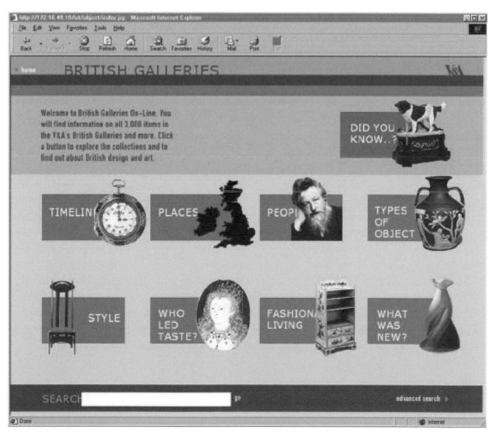

*Fig. 3.* British Galleries Online *Homepage.*

*Fig. 4.* British Galleries Online *Object Record.*

daily life would be available on the *BGO*, as well as a free text and field-specific searching of object records. In addition, associated media files would be attached to individual object records in the database. Interpretation of individual object records would be detailed and suitably worded for public access, providing contextual information about the object (fig. 4) was for and how it was used.

### Planning and Content Creation

The development of the twenty hi-tech British Galleries interactives was planned as three main phases: prototyping, full development and acceptance/commissioning.[2] In the 'prototyping' phase, seven proposed prototypes were chosen to represent a selection of the final twenty. The BG team members took responsibility for explaining in seminars and workshops the concept and content of the seven interactive displays to Oyster, who had been chosen as external service providers for the BG interactives. The Multimedia Manager for the project then gathered all the knowledge gained during initial prototyping to develop final specifications for all the gallery interactives, including the *BGO*. The BG project team defined the final content for

the *BGO* and prepared a detailed schedule for the final development. In the second phase, 'full development', the V&A began preparation of the final content.

Content creation was managed by a *BGO* Content Manager, who was appointed eighteen months before the project was to be delivered. Over 700,000 words of text were created for the *BGO* by more than 70 authors and edited by six editors. In addition 25,000 images were generated. These were prepared off-site, under the direction of the Multimedia Manager. Creation of the *BGO* content ran from September 2000 to November 2001. The plan was to deliver content in four phases corresponding to the four gallery themes. The content was divided by gallery subject and themes and modified as necessary by appointed editors.

Delays in gallery construction compressed a planned six-month commissioning and equipment installation phase into just six weeks for all twenty gallery interactives. For this reason acceptance was necessary before final software completion, and the *BGO* had to be tested over the V&A intranet rather than in the galleries to check content and functionality.

## Issues

The British Galleries database (BGd), which feeds the *British Galleries Online* interactive, was designed primarily as a project database. Initially the design of the BGd did not match the proposed *BGO* interface in terms of content collection and generation. Although the *BGO* interface was designed to give access to individual object records through the four gallery themes and four additional themes, no authority records existed in the BGd for these contextual texts. Further, the texts (on individual styles, places, people and object types) had no way of linking to the 3,000 object records. For this reason no relationship could be made between the object records and contextual data in the authority records (i.e. chairs as types of furniture). A lack of content management control within the database, e.g., controlled fields to note when record text had been edited, was another issue. The partial redesign and expansion of the BGd, instigated by the *BGO* Content Manager, ensured that each of these issues was resolved as authority records for contextual text and authority-controlled fields were added to the system.

The interactive displays were not initially designed to be Web compatible. When the proposed conversion cost exceeded the budget for the BG project, it became impossible to deliver the *BGO* or any of the other interactives on the new V&A website in 2001. Some of the interactives have subsequently been converted (e.g. Style Guides), however, no funding is currently available to convert the *BGO* and for the time being the core object information data is being hosted by the SCRAN website (www.scran.ac.uk)[2] as well as delivered via the V&A *Access to Images* site.

## Conclusions

All the British Galleries interactive displays have been very successful. A public evaluation study conducted six months after delivery showed that 69 per cent of all visitors used one or more interactive area and 64 per cent of these considered that they had increased their appreciation of the objects on display. The project as a

whole also received a BAFTA nomination for the 'Best use of Multimedia for Education purposes'. Considering this success it is unfortunate that the full visitor experience of the *BGO* is unavailable on the V&A website at present. It is also unfortunate that although much of the data within the BGd was re-purposed by loading it into the Museum's Collections Information System (CIS), this data transfer has been a lengthy procedure. The time-consuming edit of some 2,400 records by Documentation staff and the re-keying of data for the 300 records rejected from the load indicate that compatibility with CIS could have been considered more carefully when planning content creation for the project.

## Exploring Photography

### Aims

The V&A holds the National Collection of the Art of Photography, which comprises 300,000 photographs dating from 1839 to the present. From May 1998, for five years, Canon sponsored a photography gallery which was the showcase for this collection. Canon also sponsored the creation of an interactive display for the new gallery. The development fell into two phases. The first phase began in 1998 and the second in 2002. This paper describes each phase separately.

The primary aims of the 1998 project team were to deliver an interactive display that would show the diversity of the photography collection and provide an alternative perspective on the history of the art of photography. Other aims included a desire to give access to a greater range of images, to supply layers of detail and to give visitors the opportunity to choose the type of information of interest to them. One perceived need for the project was the introduction of a non-'curatorial' interpretative voice, to encourage visitors to feel confident in their own responses.

Building on the 1998 work, the aims of the 2002 project team were to convert existing content into a format suitable for hosting on the V&A website and to deliver it through a browser in the Photography Gallery. This was proposed in order to make the content accessible to a greater number of people and to encourage Web users to visit the V&A. The intention was to put the same, or a slightly edited, version of the original program on the Web. The project team aimed to simplify structure and navigation for the user without reducing the quantity of content, as well as enhancing that content with additional information.

### Deliverables

The proposed main deliverable of the first phase (1998) was a touch screen kiosk offering three different routes to audio interpretation of selected photographs. In the first section, 'Guided Tours', visitors would be able to choose from twelve audio tours from different interpreters ranging from young adults and school children to photographers, musicians, journalists and V&A curators. The second section, 'Theme Tours', would allow visitors to choose collections of photographs by themes such as architecture, fashion and landscape. The last section, 'Photographers' Stories', was intended to focus less on the individual photographs and instead offer visitors a chance to hear photographers talking about their work while viewing a selection of photographs by each of the four artists.

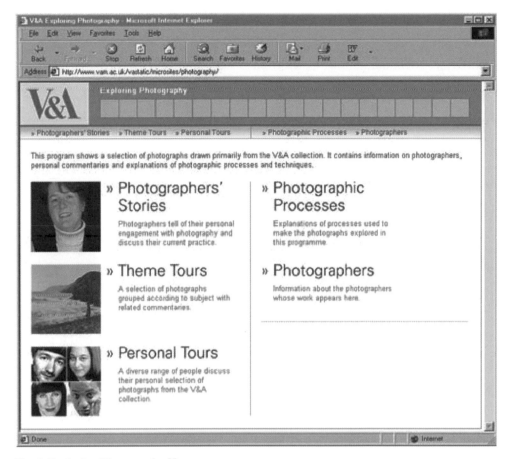

*Fig. 5.* Exploring Photography *Homepage.*

In the second phase (2002), the project team decided to deliver a mainly text-based interface, replacing audio and video with text transcriptions. This was proposed to enable a more user-friendly interface that would allow the user to approach photographs through five sections or themes. These included the three original sections ('Guided Tours', 'Theme Tours' and 'Photographers' Stories') and two additional sections ('Photographers' and 'Photographic Processes') (fig. 5). An extensive search facility was also planned as well as mouse, rather than touch screen, browsing. The look of the proposed microsite was also to be updated.

## Planning and Content Creation

In the first phase of the project, curators from the V&A Photography Section and staff from the Education Department conducted a gallery survey, asking visitors what they wanted to see in the kiosks. Using this input they produced a route map of how the project was going to work. Digital Arts which was set down in around two weeks by curators and educators. Digital Arts (a subsidiary of Canon's PR company the Sure Group) were hired to deliver the product.

Content was created by curators in the museum's Photography Section and a dedicated project staff member, who was hired for six months (using Canon funding). The main body of caption content (photographers' names, work titles and dates and photographic techniques) was taken from books, departmental records and gallery labels. Audio and film content was generated by taking some 300 colour transparencies and recording the responses to this material by various groups, from school children to art historians. This resulted in eight hours of audio and film data recorded for presentation in two identical kiosks.

In the second phase of the project, work was planned based on a 1999 gallery survey made after the installation of the kiosks in the Photography gallery. The survey results reinforced the success of the project and were useful in that they highlighted the fact that visitors responded well to the kiosks and found them easy to use. The results also showed that visitors found the sound quality poor. This was one of the issues addressed in the project planning. The second phase of the project was again planned by the curators in conjunction with the Online Museum Web development team.

Data was extracted from the kiosks by Cognitive Applications, who redesigned the interactive displays. (Digital Arts were out of business at this stage, and V&A staff did not have the expertise to work with the software (Director) used for the Digital Arts kiosks.) Cognitive Applications provided transcripts of the audio and film content, while the caption information (photographers' names, work titles and dates and photographic techniques) was re-keyed into an MS Excel spreadsheet by Photography Section staff.

The additional content for the second phase (artists' dates and museum numbers, which were added to the Excel spreadsheet) and the copyright checking was completed in four to five months. Two Photography Section staff shared the work. One member of staff also spent three weeks editing the audio transcriptions and adding two additional routes into the information through a section on photography techniques and a list of photographers. These sections had existed in the previous kiosk, but were accessible only through the object records and not on the homepage of the website. Caption information (i.e., the data in the Excel spreadsheet) was also delivered to the Web via a MySQL database.

### Issues

There were very few issues affecting the success of the *Exploring Photography* project in phases 1 and 2. Free text searching, which was originally intended but not added to the site, would have enhanced the users' browsing capabilities and led them more quickly to the information they were looking for. It is also important to note that because the terminology was not controlled, the data were neither completely consistent nor accurate throughout. Attaining copyright permission for Web use of images and text was time-consuming and some artists refused permission to re-purpose the material associated with them on the new Web version. Project staff wanted to deliver the Web version in the Photography Gallery and so this material was excluded.

## Conclusions

*Exploring Photography* has been one of the V&A's success stories. Survey results from 1999 (before the Web delivery of the project) show that in most cases users found the kiosks easy to use, that they enhanced the visitor experience and helped users to discover something new. Visitor responses to the re-worked 2003 interactive display and microsite have not yet been measured, but as the essential elements from the 1999 kiosks remain unchanged, it seems likely that they will continue to be well received.

Unfortunately, as with *Images Online* and to a much lesser extent *British Galleries Online*, the potential to create easily re-purposable data for the 2003 *Exploring Photography* Web browser was not realised. The project timescale for the redevelopment of the kiosks (May 2002-March 2003) ran parallel with project planning and content creation for the *Access to Images* project. Data could have been entered into CIS and exported to the MS Excel spreadsheet, creating parallel, Web-ready *Access to Images* catalogue records. Unfortunately, Documentation staff were forced to re-key this data into CIS, essentially duplicating the work already done by Photography Section staff.

## Access to Images

### Aims

The aim of the *Access to Images* project was to deliver object information and images to the Web for initially 10,000 objects in the V&A collections and a further 10,000 the following year. The number of objects to be delivered was agreed with the Department of Culture, Media and Sport (DCMS) as part of the V&A's funding agreement for 2002–2003. The project was organised to deliver the first tranche of object records by April 2003. The second target of a total of 20,000 records online by 2004 was also agreed as part of the V&A's funding agreement. The project intended to create a fully searchable site, delivering high-quality object information via an easy-to-use Web interface. Having learned from previous projects, staff planning *Access to Images* were careful to ensure that data was derived from primary source systems. A longer-term aim of the project was to associate the object records with wider contextual information (such as artist biographies, explanations of object types/usage and subject).

### Deliverables

The project planned to deliver data directly from CIS. The CIS database has the capability to run a search through all the available fields (free text searching) as well as searching in specific fields. The interface would offer this search capability to Web users (fig. 6). Two different search screens, a simple and an advanced search, were provided. Once retrieved through a search, object images would appear in a 'lightbox' format from which the user could select individual object records to examine in detail. As with the *BGO*, the interpretation of individual objects would offer detailed information to users. A small selection of CIS data elements would be provided, including artist/designer name, dates, dimensions, techniques etc., along with

*Fig. 6.* Access to Images *Advanced Search Screen.*

the free text description of the object. This descriptive text would be worded suitably for public access, providing contextual information about an object's form and function, as well as why it is interesting or important (fig. 7).

## Planning and Content Creation

Project planning for *Access to Images* began with a project proposal to the V&A Management Board outlining the scope and purpose of the project, the objectives and the three main sections of the project: image/data quality, technical approach and resources/timescale. This proposal was prepared by the Director of Learning & Interpretation, Head of V&A Enterprises, Head of Information Systems Services, Head of Records and Collections Services, Head of Photography and Picture Library and the Director of Collections Services and was approved by the Management Board in June 2002. After an initial meeting of the project team in July 2002, the team was divided into two planning groups: a Technical Group, which decided the technical issues and requirements for the project (interface design, field selection, image standards and authority-assisted searching) and a Content Group, which defined content requirements and issues (interface content, creation of content, potential sources of content, copyright, data clean-up, the approval process and data presentation). The groups met approximately every two weeks and would also link up to discuss overall plans.

*Fig. 7.* Access to Images *Individual Object Record.*

One of the most important developments to come out of the project technical specification was the merging of CIS and the Photo Catalogue, which was achieved in February 2003. Images in the Photo Catalogue were visible in CIS through a direct link (rather than via image records as previously). Object data from CIS were similarly visible in the Photo Catalogue, and hot links allowed instant movement between systems. A new 'Access to Images' layout tab was also added to CIS in December 2002 to enable contributors and editors to see all the Web-delivered fields. The fields selected to appear on the Web were Object Name, Museum Number, Title, Artist/maker (name and dates), Date and Place of attribution, Materials and techniques, Dimensions, the Public Access Description and Credit Line. Additional fields – Subjects Depicted, Category and Styles/Periods – are not displayed, but are searchable key words on the Web interface.

The design and development of the Web interface was a collaboration between the V&A Design Section, the V&A Web development team and Systems Simulation Ltd who supplied the software. The interface was ready by January 2003 and was the first microsite on the V&A website to comply fully with the new V&A brand style (colours, look etc.)

Content sources were decided by the Content Group based on two principles: first, an image (either analogue or digital) being present in the Photo Catalogue, and hot links second, on reliable object data already existing either in CIS or in easily accessible sources. For this reason a load of 3,000 records from *BGO* made up a large part of the

2003 target of 10,000 records. The remaining 7,000 records were generated from existing publications (where data and images were easily accessible), from other electronic data-loads (for which image scanning would be initiated) and from data already available on the Web via *Images Online* and the 'Grand Design' exhibition microsite (which had to be manually entered into CIS by Documentation staff). Content creation was managed by the Documentation Manager, who is head of Records Section, part of the Collections Services Division. Detailed guidelines for the creation of *Access to Images* catalogue records were written by the Documentation Manager and passed to the Collections.

Content creation began in October 2002. Contributions to this content were made both by Curatorial Departments and Documentation staff in the Records Section. The Curatorial departments agreed to deliver content for three deadlines, the last of which fell less than a month before 1 April 2003 the project delivery date, leaving very little time to edit the material. *Access to Images* delivered text and image content for just under 10,000 objects in April 2003. Over 70 authors and a team of copy editors contributed to the project. In the second year of delivery (ending March 2004), content contributions were delivered on a monthly basis and were again generated from data-loads and publications. However, the organisation found its target more difficult to deliver in this second year.

### Issues

The decision to go ahead with *Access to Images* in July 2002, leaving eight months to plan the project and begin content creation, meant that contributors were faced with a short time to identify and deliver content. Although all content contributions were planned in advance and mainly re-used existing data (i.e. did not require new research), not all contributors were able to deliver the full number of proposed contributions for any of the three deadlines. The timescale and the apparent one-off nature of the project meant that instead of creating content as part of the Museum's everyday 'business', *Access to Images* was viewed as a finite project.

Based on the experience of creating the *BGO*, an approvals system was designed for the 2003 *Access to Images* records to ensure data quality and accessibility. Text records were signed off by four different groups: Collections (as authors), Educators (content review), Records (structured text edit) and the Copy Editor (free text edit). Having had to abandon the content review in 2003 due to lack of resources, it became apparent that it was not feasible for educators to check each individual record. Subsequently educators reviewed a sample of texts by each author and then fed back comments through the Documentation Manager to the Curatorial staff. Managing the free text editing process using contract staff proved time-consuming and complicated, and Documentation staff felt uncomfortable dealing with this aspect of the project.

While senior management support for the project existed, it could have been made both more vocal and more visible. Issues with museum-wide communication about the importance of *Access to Images* and its tie-in with the Museum's Funding Agreement meant that some V&A staff did not 'buy in' to the project at an early stage. Senior management could have positively influenced these early opinions.

## Conclusions

In future we aim to improve the mechanisms to manage the workflow of *Access to Images*. Collections Services intend to focus on contributing in its area of expertise and encouraging other departments to do the same. They would like to share the ownership of the project with the Collections and Interpreters while continuing to contribute to the project. Instead of the content creation being solely managed by the Documentation Manager, Collections will take ownership and control of their contributions. In their role as interpreters of the collections, curators and educators will work together to determine how and what they should present to the public, whether those descriptions need editing and, if so, how the editing process should be managed.

It is clear from looking at each of these projects that certain factors can adversely or positively affect the success of a project. Time is an important factor in each of these projects and when it is placed as a constraint, it can impact negatively on the results of a project, as was the case with *Images Online*.

Planning is one of the most important factors for the successful delivery of any project. A lack of planning can mean that problems which might have been foreseen are not resolved as with the *Images Online* project. In the case of *Access to Images*, it was planning that essentially saved the project. A strict editing procedure for records implemented from the outset enabled the project to deliver consistent data despite tight deadlines.

The importance of creating data that can be re-purposed is essential today when resources are limited and expectations for ever greater access to electronic information are high. While the *Exploring Photography* project was successful in terms of delivering contextual information and an easy-to-use interface, data re-purposing was never considered in the project planning for either project phase. The *BGO* development did consider data re-purposing and for this reason it could be used to contribute significantly to the first *Access to Images* target (i.e. one-third of the total). It is essential that the V&A ensure that all data creation, e.g., for microsites and interactive displays, should be re-usable for future projects.

When planning a project it is important that staff involved in creating content experience 'buy-in' to the project and feel ownership of it. In the case of the *BGO*, the high profile of the British Galleries project and its support by senior management had a very positive effect in encouraging contributors to 'buy-in' to the content creation. This has not been as much the case for *Access to Images*. However, in its third year of delivery, with content coming much more from the V&A 'everyday business' (acquisitions, publication, exhibitions etc.), staff have begun to make a more obvious long-term commitment to the work.

## Future plans

What does the future hold for the V&A in terms of system developments? How can we expect to see these lessons built on in future projects?

The Technical Group responsible for the creation of the *Access to Images* Web interface has recently reconvened and is meeting regularly to discuss the ongoing development of the application. The group is considering a number of options to

enhance the user experience. These will be informed by the results of a user survey recently carried out by the Web development team. The survey collected the responses of over 300 users, examining why they use the *Access to Images* site and measuring many aspects of their user experiences. The results show that *Access to Images* has been very well received and users have responded positively to most aspects of the site, particularly the quality of the images. Users want access to more object records and images, as well as help finding objects and clues as to what is available. This has prompted the Technical Group to consider developing browsing further, e.g., by artist name, object type etc., as well as search enhancements such as improved date searching and searching for related objects.

The Museum is embarking on a Core Systems Integration Project which aims to integrate all the systems at the V&A. The aim is to deliver to any interface such as a gallery interactive display or Web application by taking and refreshing data from the Museum's core systems: CIS and the Photo Catalogue, the National Art Library database, Concise (the conservation information system) and the Loans Module. This will mean that if an interactive display such as the *BGO* is planned in future, accurate data from each of these systems will automatically be available to the project management system and can be delivered directly to the gallery and the Web. This opens up many avenues for development and points to a future where data from all museum systems can be easily manipulated to deliver services and access to the on-site and online visitors of tomorrow.

## Acknowledgements

Many thanks are due to Frances Lloyd-Baynes, Head of Records at the V&A, who contributed to this paper. Thanks are also due to the following for talking to me about individual projects: Martin Barnes, Kate Best, Peter Ford, Mark Hook, Alan Seal, James Stevenson and Seonaid Woodburn.

## Notes

1   Lloyd-Baynes, F. (forthcoming), 'Managing the Unmanageable: Lessons in Content Management from the V&A's British Galleries Project', *Dramaturgy in Museum Communication: The Change of Meaning in Virtual Spaces*.

2   Editor's note: Scran (www.scran.ac.uk, active 2 February 2006) is part of the Scran Trust – a registered charity – whose aim is to provide educational access to digital materials representing material culture and history.

# This is the Modern World: Collaborating with ARTstor

Vickie O'Riordan

Many of us working in visual resources today are simultaneously creating and curating dual-image collections we are caught somewhere between the old analogue slide and its digital future. While it is fairly easy to take old media and spin them like alchemy into something new, to remake our slide collections over into digital collections, it is all the things associated with this transformation – funding, higher level staffing, issues of copyright, metadata creation and access, digital storage and preservation – that make this process complex. Sharing expertise in these areas will help propel us into the digital future. Collaborative efforts create opportunities and products that are often impossible to achieve at a single institution.

The *Oxford English Dictionary* defines collaboration as 'united labour'. This beautiful term brings up a sense of both equal work and equal reward, of efforts shared and, at the same time, enriched. Certainly this is a good description of the work between the University of California (UC), San Diego and ARTstor.

A grant from the Mellon Foundation enabled UC San Diego to contribute over 200,000 images and accompanying cataloguing data from the UCSD Library's slide collection to ARTstor's Digital Library. On the one hand, the grant resulted in a rather simple exchange of goods. Collaborating with ARTstor gave UCSD a copy of the high-quality digital images created for the grant. In turn, ARTstor, working with UCSD, quickly amassed the initial material they needed to seed ARTstor's Image Gallery. Successful collaborations are never limited simply to the products they create. While this paper is concerned with the activities of the grant, I am also interested in the areas that surround it. What made the UCSD Libraries an attractive partner for ARTstor? What were our experiences working with ARTstor's metadata team and what were the lessons learned during the year-long beta test of ARTstor on our campus?

## The UCSD Slide Collection

The UCSD slide collection goes back to the very early days of the campus in the late 1960s and the creation of the Visual Arts Department which was an early and important contributor to the collection. The department was highly theoretical and their mission, in part, was to break down the boundaries separating artists, art historians and art critics. This goal and the ephemeral nature of the art being created by the faculty at the time guaranteed that the images requested to support instruction would be both broad and eclectic.

At the same time, because the slide collection was part of the library, its mandate was to serve the entire campus and images were requested to support all academic departments. So along with traditional art images, one could just as easily discover

a page documenting poses during a fit of hysteria for the Sociology Department, a poster for the film *Willie Dynamite* ordered by a Communication professor teaching a class on Blaxploitation films, or a series of falsified photographs documenting Stalin's elimination of his rivals for the History Department. Since patrons came from all disciplines it was important to offer effective ways to search the collection, from the expert art historian to the first-time undergraduate user. For example, physicians from the School of Medicine looking for images to help illustrate their lecture on smallpox might want to find an illustration from an Aztec codex documenting the disease.

So when the slide collection went online in 1986, the decision was made at that time to create a full catalogue record for each slide in the collection and to include subject headings. And though this early version of the slide database was an efficient tool for the cataloguers, offering linked authority records and specialised templates for hundreds of media, it was a far less effective database for patron use. All subject headings were entered as a simple string of terms and separated by commas. In fact, personal names could only be entered in direct order. At the same time, these subject terms were notoriously difficult to retrieve. Searches for all records with the subject 'portraits' would have to be mediated by a cataloguer who would write a query for a report that would take several hours to run. This meant there was no easy way for patrons to find images under a specific subject or for the cataloguers themselves to quickly check previously-used subject terms.

All this would change in the mid-1990s when the library made the decision to move the image records into the UCSD Libraries online catalogue. The goal was to unite all the specialised templates to one 'ideal' record. This was difficult task because it required moving from a relational database to a flat file. A team was formed consisting of both image and book cataloguers working together to convert the image records into the universal library language of MARC.

This new world of book cataloguing seemed overly restrictive and somewhat bizarre to the image cataloguers. Up to this point the UCSD image cataloguers had always done their work in relative isolation and followed their own local rules and practices. Now the image cataloguers were introduced to a world where rules, no matter how strange, had to be obeyed. If using 'Ray, Man' as an authority heading for the artist Man Ray, or separating and renaming the Starn Twins to Doug and Mike seemed silly and the rule was ignored, the image cataloguers quickly heard from a section in the library's catalogue department called database maintenance. Here all rules were enforced.

Though difficult for the cataloguers at first, this move to the wider world of the library was essentially a positive one. The image cataloguers lost the extensive linked authority records and specialised templates of their old database, but the shift to the library catalogue offered more opportunities to unite the data and resolve redundancies in both name and subject headings. Now all subject terms were divided into four separate indices and the source of the terms used was indicated by an assigned number. This resulted in a cleaner database which offered far more efficient searching with immediate results. A patron interested in finding all images with the subject 'history painting' could now click on the link to find all uses of the term in the collection.

On a more mundane level, each slide in the collection was now given a barcode which made it possible to track not only usage but its physical status and its disposition during its lifetime – whether it was discoloured, lost or re-shot. This information led to a more consistent form of slide and record maintenance. So, when ARTstor looked for a partner, they found at UCSD a relatively young and well-maintained slide collection. The collection contained a broad range of images with a complete catalogue record for every slide in a universally accepted and well-known format. A full online cataloguing manual was available to explain the logic of the collection. In addition, each slide had the all-important barcode which would keep track of the physical collection during the grant phase and would prove essential later as the unique identifier used to unite the digital images back with their cataloguing data.

## The Grant

Work on the grant started in early 2002 and was done at UCSD primarily by the Visual Resources staff with some technical help from the Library's Information Technology Department. The grant required a continual cycle of shipping and receiving 25,000 slides per month. The slides were pulled, cleaned and packed into bins. The library's bindery truck delivered the slides to a vendor located in Los Angeles selected by ARTstor.

The physical pulling, cleaning, packing and unpacking of the slides were time-consuming, but essentially not difficult. Grant money had allowed UCSD to hire a small army of student workers and to refashion an area of the Visual Resources Collection specifically for this work. The fact that the Visual Resources Collection remained open and the slides were continuously used by faculty and students during the years of the grant required a high level of communication between UCSD, ARTstor and the vendor. Obviously deciding which groups of slides could leave campus for a two-month period had to be driven exclusively by faculty use.

The decision to send what and when became something of a war-room activity for the Visual Resources staff. Many hours were spent searching class schedules and previous course outlines for clues to project use, and, of course, we worked closely with the faculty and asked for their feedback.

The ARTstor staff made this piece of the grant work far easier for the Visual Resources staff by being totally committed to the needs of the faculty at UCSD. And so, while it may have been better for ARTstor to receive a slide shipment of Italian painting, they were wonderfully gracious when we sent postcard art and ice sculpture instead.

After amassing and parsing out all the projected slide deliveries, a project website was created. The online schedule page was heavily used by the faculty as it detailed the group of slides to be sent, dates of slide departures and arrivals back on campus.

In the end a bigger issue than sending slides off-site appeared. Initial quality control was to be done by the Visual Resources staff since we had the original source material. Once the vendor had scanned the images the digital files were delivered to UCSD on drives. Files of that size and type were relatively new to the library and

a system to run checksums and load the files to the library servers took some time to put into place. By the time the Visual Resources staff could see the images, there was a small backlog of drives. Once the quality control work started, we discovered that during the vendor's post-process work the editors were sometimes over-enthusiastic in their 'enhancement' of the digital images.

The Visual Resources staff realised that quality control would have to be more intensive than previously planned and, when needed, a system of re-scanning should be established. During this period the ARTstor staff had been hard at work creating a robust digital asset management system, or DAM, to keep track of all aspects of the work on the digital files. ARTstor greatly facilitated our efforts at quality control by allowing us to hire additional staff and generously permitted the Visual Resources staff partial use of the ARTstor DAM. This helped the Visual Resources staff to keep track of a series of scans and re-scans which required a delicate and synchronised method of file deletions and additions between UCSD, the vendor and ARTstor.

## Metadata

Along with images, the Visual Resources Collection also supplied the accompanying cataloguing data to ARTstor. Our collaboration with the metadata team at ARTstor and their analysis of our work was truly a revelation to the image cataloguers at UCSD. Our collaboration with the metadata team allowed us to see our records in an entirely new light. Having been through one major re-mapping of the UCSD image records, the cataloguers felt there was little more to learn about the UCSD image data. But ARTstor's Emerson Morgan was not only a metadata genius; he was also wickedly thorough in his analysis of our records.

The ARTstor metadata team as a whole was ingenious at running reports that revealed both human and machine errors in our records. These efforts by ARTstor allowed the image cataloguers to clean up certain errors which up to this point had been overlooked, given the limitations of running these same types of reports in the library database.

This part of our collaboration with ARTstor also gave the image cataloguers the opportunity and the support to work on a long-desired clean-up project as well as newly-recognised enhancements to the cataloguing data. Our work in creating a clean, useful and searchable image catalogue, which started with the move to the library database, was extended and greatly improved in our collaboration with ARTstor.

## The Beta Test

Finally, this collaborative spirit was carried on into the ARTstor beta test. During the test, the Visual Resources staff worked with an entirely new ARTstor team and found the same sense of openness and generosity. In some ways UCSD was in a unique position to give ARTstor feedback since many of the records from the Visual Resources Collection made up ARTstor's Image Gallery at that time.

Our remote location, though, presented a real challenge to the ARTstor team. The other twelve beta test sites were located in and around the New York area. Our location on the West Coast required that the ARTstor team tackle issues effectively, not

only from a great distance but often under serious time constraints. The ARTstor staff had to be extremely responsive – this was especially true for the technical staff. They did not have the luxury of an easy site visit to untangle any complex technical issues that might come up during the testing period.

The most important lesson we learned during the year-long beta test was that faculty were truly interested in learning about and using new technology. This was especially true if it made them more effective in their teaching and more efficient in their classroom preparation. At the same time they had little patience for technology that did not work well the first time. They had even less patience for technical malfunctions that interrupted the flow of a lecture. To be successful in our beta test at UCSD, we knew we would have to have everything running smoothly long before the faculty ever arrived in the classroom.

The beta test became a wider collaboration at this point. Using digital images requires 'smart' classrooms, and we are fortunate at UCSD to have them campus-wide. Making 'smart' classrooms work required effective collaboration with many campus departments, such as the Media Centre, Office of Network Operations, and Academic Computing. The ARTstor team played well with these various campus departments; they were able to speak their language and follow through when asked to make technical adjustments that were specific to the needs of UCSD.

During fall quarter we worked with Marta Hanson, a history professor teaching an undergraduate class on Chinese culture and civilisation. Professor Hanson's excitement at discovering a tool like ARTstor where she could search a wealth of images, easily create groups and folders and then manipulate the images in the classroom (in ways previously impossible with slides) was quickly conveyed to fellow faculty members, and, by winter quarter, we had increased our user base. With the increased faculty use during winter quarter, UCSD was able to give the ARTstor team some excellent feedback on both tools and the general usability of ARTstor's Digital Library. In turn, the ARTstor staff were quick to respond with a series of requested enhancements.

The real test of ARTstor, though, came in spring quarter when we worked with Rita Keene, a faculty member teaching a large undergraduate art history survey class. This class had over two hundred students and five teaching assistants leading seven additional study sections each week. Training the five teaching assistants revealed a microcosm of users. The graduate students ranged from the intensely computer-literate as one would expect, to several less than interested in anything technical. The fact that all five graduate students were using ARTstor well within a day or two of training speaks to its ease of use.

Owing to the size of Professor Keene's class, we knew this would be a terrific test of ARTstor's reliability, and since ARTstor would also be the only access for Professor Keene's students to study the required class images, we viewed this class as a true test of ARTstor's scalability. In early April 2003, right before the mid-term examinations, the students began to log on to ARTstor to study the class images and there was a steep increase in use. I am proud to say that UCSD, in the spirit of true collaboration, gave ARTstor an excellent test of usage and capacity planning. Even with the tremendous spike in use, the students were able to view the study images.

On the other hand, off-site connectivity was an ongoing issue during the test period. This is more of a campus rather than an ARTstor problem. Most users, faculty and students alike, would rather prepare for class off-campus.

At UCSD, the Office of Network Operations (ONO) is in charge of campus network security. At the same time it acts as the official gatekeeper for faculty and students attempting to connect to licensed databases off-site. In this sense ONO is a profoundly conflicted department. While offering a dazzling array of ways to connect off-campus, they are deeply pessimistic about one's ability to do so.

To help ARTstor users at UCSD, we created a page that walks them through ONO's proxy process step by step. While not a perfect solution, this resulted in fewer problems with our proxy connections. Difficulties with off-site access are not just an issue for UCSD. This is a much larger problem that needs to be addressed. In a perfect world it should be easy and 'invisible' to the user when connecting to any licensed databases from anywhere. In a further collaboration with ARTstor, the UCSD Libraries hope to test an authentication system called Shibboleth as a means of trying to improve off-campus access.

We surveyed the students at the end of Professor Keene's class. What we had suspected about use was confirmed by the results. Most of ARTstor's use came from off-campus. We also discovered that keyword was by far the method of choice when searching for images in ARTstor which is pretty ironic given all our hard work on the perfect subject heading.

The satisfaction rate of ARTstor from our student survey was high. They especially liked ARTstor's 'image group print preview' function which gives them a quick and printable flashcard for study purposes. The introduction during spring quarter of ARTstor's 'Offline Image Viewer' (OLV) was a major turning point for our faculty. Even those dedicated to PowerPoint quickly deserted it as the Offline Viewer offered the offline safety net they craved with far more functionality than PowerPoint.

The recent enhancement which allows users of the OLV to upload their personal images into ARTstor is something the faculty at UCSD have long seen as essential to their digital needs.

I began my paper by stating that successful collaborations are never limited simply to the products they create. In fact our metadata from the grant has been utilised in two significant collaborations. A grant from US National Archives and Records Administration (NARA) provided the funding for collaboration between the UCSD Libraries, the San Diego Supercomputer Center and the libraries at Massachusetts Institute of Technology. Work on the grant will integrate two systems, the Storage Resource Broker and DSpace, which will work together to collect, manage, store and disseminate digital objects more effectively. The UCAI project, which is funded by the Mellon Foundation, is working on the creation of a large-scale union catalogue for image metadata which will reduce redundancies in image cataloguing.

UCSD is just one of many partners working with ARTstor, but our collaboration with them has fundamentally changed for the better the way faculty and students use images. Our united labour proves that the digital future of shared collections and expertise is viable.

# Towards a Semantic Web: The Role of Ontologies in the Literary Domain

Luciana Bordoni

## Introduction

Natural languages are the main vehicles for conveying the content of digital products in business, education and culture. The use of semantics in information retrieval and filtering can increase the performance of document retrieval systems and software. Semantics allow the retrieval of documents that are conceptually similar regardless of how they are written. For this purpose an extensive vocabulary is needed. Shared conceptualisation of specific domains (ontologies) could offer a means to face this challenging task. The ability that ontologies have of structuring information as a hierarchy of concepts helps experts to establish agreement both on specific domain concepts and on common-sense knowledge.

The application of ontological resources in the cultural domain may offer a useful means to face, on the one hand, the ambiguity of natural languages and the need for finer meaning discrimination in the written description of digital documents (text, images, etc.); and, on the other hand, the retrieval of relevant information.

Ontology-based description can extract implicit concepts hidden in a document; for this purpose a conceptual reference model for the interchange of cultural information is needed. Many definitions of ontology have been offered. One of the most commonly cited definitions is offered by Gruber: 'An ontology is a formal explicit specification of a shared conceptualisation.'[1] A conceptualisation is an abstract, simplified view of the world that we wish to represent for some purpose. Every knowledge base, knowledge-based system, or knowledge-level agent is committed to some conceptualisation, explicitly or implicitly.

Tim Berners-Lee, the creator of the Web, considers ontologies to be of critical importance to the development of a Semantic Web: 'The first phase in the evolution of the Semantic Web may be the development of decentralised adaptive ontologies for software specification.'[2]

Ontologies are the Rosetta stones of the Semantic Web. They provide two things: taxonomies and inference rules. Both are important devices for representing and managing knowledge. One of the key promises of the Semantic Web is that it will provide the necessary infrastructure which will enable services and applications on the Web to automatically aggregate and integrate information. Archives, museums and libraries are making enormous contributions to the amount of information on the Web through the digitisation and online publication of their photographic, audio, film and video collections. The Semantic Web is an activity of the World Wide Web Consortium (W3C) and aims to provide tools that enable resources on the Web to be defined and semantically linked in order to facilitate automated discovery,

aggregation and re-use across various applications. The Web Ontology Working Group are currently developing a Web Ontology Language (OWL) in order to define structured ontologies which will provide richer integration and interoperability of data among descriptive communities. Ontologies are often seen as the building blocks for the Semantic Web, as they provide reusable knowledge about specific domains. Furthermore, ontologies have been accepted as powerful descriptive tools, and, for this reason, they are appropriate for playing the role of semantic views. Currently, there is a great deal of interest in the development of ontologies which will facilitate knowledge-sharing in general and database integration in particular. Thus, the main purpose of an ontology is to make content explicit in a manner independent of underlying data structures. Ontologies are thus abstractions and may describe different types of data organisation for example, relational tables and textual and image documents. In this paper the complexities of using ontologies in literary research are explored. The paper discusses a case study which demonstrates how the application of the WordNet ontology for word sense disambiguation may help the understanding of a literary phenomenon.

## Ontologies and Knowledge-Sharing

The availability of electronic textual information is amplified today by rapid advances in information and communications technology. Among the immediate consequences, the need for a more efficient, personalised information access and management system is becoming increasingly apparent, pushing the ICT industry to find new solutions in the field of knowledge management.

Knowledge-based systems and services are expensive to build, test and maintain. A software engineering methodology based on formal specifications such as shared resources, reusable components and standard services is needed. The specifications of a shared vocabulary could play an important role in such a methodology. However, a number of technical problems stand in the way of shared, reusable knowledge-based software. As with conventional applications, knowledge-based systems are based on heterogeneous hardware platforms, programming languages and network protocols and, therefore, impose special requirements for interoperability. In the meantime, the reality of semantic interoperability is not encouraging. It is only in the cultural arena that dozens of 'standard' and hundreds of proprietary metadata and data structures exist, as well as hundreds of terminology systems. Recently more research projects have begun to support the use of formal ontologies as common conceptual schema for information integration in order to: provide a conceptual basis for understanding and analysing existing data structures and instances; give guidance to communities beginning to examine and develop descriptive vocabularies; and develop a conceptual basis for automated mapping amongst metadata structures and their instances.

In a knowledge-based system, what 'exists' is what can be represented. In a declarative formalism the set of objects representing the knowledge of a domain is called the 'universe of discourse' (e.g. classes, relations, functions or other objects). This set of objects, and their relationship to each other, is reflected in the representational vocabulary by which a knowledge-based system represents knowledge. In text-mining applications the need for a shared domain knowledge is also evident.

Generally, these applications are based on uniformly formatted ontologies for which homogeneity of conceptualisation is assumed. Ontologies may also be compared to conceptual schema in database systems. While a conceptual schema defines relations on data, an ontology defines terms by which knowledge is represented. An ontology defines the vocabulary used to compose complex expressions such as those used to describe a planning problem. The utility of common ontologies as knowledge-sharing is an interesting hypothesis. Ontologies reduce conceptual and terminological confusion by providing a unifying framework within an organisation. In this way, ontologies enable shared understanding and communication between people with different needs and viewpoints arising from their particular contexts. Ontologies are used in e-commerce to enable machine-based communication between buyers and sellers; vertical integration of markets; and description reuse between different marketplaces. Search engines also use ontologies to find pages with words that are morphologically different but semantically similar. Moreover, ontologies may enhance the functioning of the Web in many ways. They may be used in a simple way in order to improve the accuracy of Web searches. More advanced applications will use ontologies to relate the information on a page to the associated knowledge structures and inference rules. An ontology typically contains a hierarchy of concepts within a domain and describes each concept's crucial properties through an attribute-value mechanism. Further relations between concepts might be described through additional logical sentences. Finally, constants (such as 'February') are assigned to one or more concepts (such as 'Month') in order to assign them their proper type. A number of factors drive the need for ontologies in knowledge management. Ontologies facilitate reusability of artefacts archived in the knowledge management system as well.

## An Ontology-Based Approach in the Literary Domain

Studies on ontologies are receiving growing attention essentially owing to the advent of Web services. The Semantic Web represents a new direction in the area of knowledge representation as the attempt to make information, texts and knowledge shareable among the different actors involved in the scenario of a Web application. From the point of view of language and text processing, the Semantic Web represents a challenge in several directions. Linguistic capabilities are needed in at least two major areas of the Semantic Web. First, a strong linguistic ground is needed for expressing domain ontologies, i.e. the facts about a domain that are in fact critical to the inferences of the target Web application. An ontology is thus seen as a theory about a domain and it obeys specific logical constraints (e.g. description logics). However, it is usually expressed in linguistic terms, whereas relations and entities are first named by the knowledge engineer. A second aspect that makes the Semantic Web very relevant for research in Natural Language Processing (NLP) is that a Web document is a textual object. Ontologies may be helpful in removing ambiguities in terminology and meaning. Lexical ontologies provide a huge collection of concepts representing the meanings of words in a language. The application of ontological resources in the cultural domain may offer a useful means to face the needs of accessing cultural heritage for the retrieval of relevant information – useful for the preservation of cultural heritage (visual arts, etc.) and for academic studies (i.e. in the humanities).

For the interchange of cultural information, a conceptual reference model is needed because the content of cultural digital products (documents, photographs, films, etc.) is usually conveyed by heterogeneous descriptions, expressed in natural language. From the user's point of view, finer descriptive terms and easier access to multi-lingual cultural content are needed.

Ontology-based description can extract implicit concepts hidden in a document: on one hand facing the ambiguity of natural languages and allowing the retrieval of conceptually similar documents regardless of how they are written; on the other hand providing an interlingual, conceptual framework for accessing multilingual information sources.

The task of retrieving relevant cultural products from the Web is not the only successful application of the capability that ontologies have of extracting implicit concepts which are hidden in text, photographs and films in digital form. Knowledge acquisition is a long-standing problem in both Artificial Intelligence and NLP. Huge efforts and investments have been made to build repositories with semantic and pragmatic knowledge.

Ontologies may play a really important role as interpretation aids even in complex domains such as literary research.

In the interpretation of a literary phenomenon the heterogeneity of the sources of information to be selected determines the success in finding relevant documents, gathering and connecting historical, geo-political and cultural information. The Visual Contextualisation of Digital Content (VICODI) project enhances users' understanding of digital content in the domain of history.[3] VICODI is one of the very few existing systems that exploit a fully-fledged ontology for the purposes of information extraction and intelligent information retrieval.

The process of traditional research in a humanities field can be summarised as follows: focusing on a literary phenomenon; examination of the literary production of an author; selection of relevant publications; study of selected publications; extraction of results of the research.

In order to demonstrate the needs of humanities research and how to find a relevant document, two literary case studies have been investigated.[4]

The methodology comprises the selection of keywords, able to express the essence of the literary phenomenon under analysis; and the consultation of a lexical database, that allows a semantic agreement to be reached on the meaning of keywords and to limit their semantic field.

Over the recent years 'wordnets' have become important resources for NLP. The success of the Princeton WordNet has motivated the development of several other wordnets for numerous other languages. (http://www.globalwordnet.org) Wordnets are lexical semantic networks built around the concept of a 'synset', a set of lexical items which are synonymous in a certain context. Semantic relations such as hyperonymy, meronymy and antonymy link synsets to each other and it is these semantic relations that give wordnets their essential value. The number of semantic relations among synsets is an important criterion of a wordnet's quality and functionality.

The core of the methodology in the case studies is the use of WordNet, a lexical database (freely available online), working as a reference ontology.[5] WordNet definitions (glosses) allow the humanities researcher the exploration of the semantic fields of keywords, clarifying in this way the conceptual domain of the literary phenomenon under analysis.

The process of identifying the meanings of words in text is known as word sense disambiguation (WSD) and this has been extensively studied in language processing. One of the main challenges in using a resource such as WordNet is discovering which of the synsets are appropriate for a particular use of a word. WordNet synsets are organised into a hierarchy with more general concepts at the top and more specific ones below them. So, for example, *motor vehicle* is less informative than *taxi*. The similarity of two synsets can be found by choosing the synset which is above both in the hierarchy with the highest information content value (i.e. the most specific). By extension of this idea, sets of nouns can be disambiguated by choosing the synsets which return the highest possible total information content value. Basically, language needs two kinds of words to work efficiently: general words, which may be used in a variety of contexts (and which have a variety of related meanings) and specific words with more precise meanings that have very few relevant contexts. A specific word which has a unique context 'diversifies' language. A preponderance of either general or specific words makes language inefficient. The 'force of description' in document representation dictates that documents, especially the intellectual content, should be described as completely as possible, so that all of the information in the document is faithfully represented. This makes the representation of any given document easier to predict for the searcher. Documents are often represented by a description of their content and their context. The content concerns the subject of the document, what it is about. The context of the document describes the internal or external 'framework' of the document.

In the next section, two case studies will be presented in which a semantic structure of a corpus is analysed.

## The Case Studies

Natural language is a redundant medium that allows the use of more than one possible sign to refer to the same object in the world. A term, which we take to be a simple or complex noun phrase, can refer to more than one concept and the other way around. That is, the ontology of concepts that represent the world, on the one hand, and, the terms in the language, on the other, have a many-to-many relationship. Therefore, in applications of natural language understanding such as document classification and information retrieval, we need to undertake a semantic normalisation that maps similar terms to the same concept. Terms may describe complex concepts, for example: objects being modified in certain ways, undergoing actions and having relations with other objects. The critical study of a literary work usually starts from the identification and analysis of specific narrative phenomena.[6] A computational tool able to support a critical study should identify and model these aspects: a representation of the narrative phenomena as an explicit knowledge model is thus needed. For instance, a knowledge model could represent and hierarchically organise the use of figurative language. The task of finding and modelling interesting

narrative phenomena should be intended as a cooperation between a pool of critics skilled on a specific author and a pool of knowledge engineers. The experts should identify the most interesting narrative events, while the engineers should be responsible for organizing the events in an unambiguous explicit knowledge model. The final result will then be a reference ontology of narrative elements.

The aim of the present experiment is to examine the work *Dualism: Truth vs. Propaganda* by the Austrian intellectual Karl Kraus (1874–1936) as a case study for its literary value and the short story *Cloud, Castle, Lake* (1941) by Vladimir Nabokov (1899–1977) as a case study for its exemplification of narrative phenomena.[7]

In the first case study, it is possible to be explicit about what is linked to the concepts of *information* and *propaganda* and (consulting the definition of *journalism*), an objective basis for the concept of *journalism*, as intended by Kraus. The validity of Kraus' position on information problems has been confirmed by the disambiguation of the keywords and the exploration of their semantic fields carried out using WordNet.

The second case study began with the translation problem that arose from the sentence 'anonymity of all parts of the landscape'. By using WordNet definitions, the analysis of a number of terms from the story has led to a better understanding of the roles and relations among the characters involved in novel, thus achieving a translation closer to the writer's purposes. The experimental results suggest that a new framework for literary study that better harmonises computer-based analysis and the expert's preferences will allow a more powerful perspective on proactive human-machine 'literary' interfaces.

## Conclusions

In this paper the need for a shared understanding to overcome barriers communication between people, organisations and software systems has been demonstrated. Such a shared understanding (i.e. ontology) can work as a unifying framework giving rise to a variety of benefits. I have also presented the effective application of an ontology-based approach in literary research.

There are a number important issues and opportunities for ontology research which require further exploration: Development of ontologies as inter-lingua to support interoperability among tools in some domains; development of tools to support ontology design and evaluation; development of libraries of ontologies; development and integration of new ontologies; methodologies for the design and evaluation of ontologies.

## Notes

1    Gruber, T. R. (1993), 'A translation approach to portable ontology specification', *Knowledge Acquisition*, 5, pp. 199–220.

2    Berners-Lee T., Hendler J., and Lassila, O. (2001), 'The Semantic Web', *Scientific American*, May.

3    Nagypál G., Deswarte R., Oosthoek, J. (2005), 'Applying the Semantic Web: The VICODI experience in creating visual contextualization for history', *Literary and Linguistic Computing*, 20:3, pp. 327–349.

4   Alderuccio D., Bordoni L. (2002), 'An Ontology-based Approach in Literary Research: Two case-studies', *Proceedings of the Third International Conference on Language Resources and Evaluation*, Las Palmas de Gran Canaria, Spain, 29–31 May 2002, pp. 1186–1190.

5   Miller G.A. (1995), 'WordNet: A lexical database for English', *Communications of the ACM*, 38:11, pp. 39–41.

6   Basili R., Di Stefano A., Moschitti A., Pennacchiotti M. (2005), 'Automatic Analysis and Annotation of Literary texts', *Proceedings of AI\*IA 2005 Workshop on Cultural Heritage*, Milan, 20 September 2005.

7   Arntzen, H. (1975), *Karl Kraus und die Presse*, Muenchen: Wilhelm Fink Verlag. Nabokov, V. (1959), In *Nabokov's Dozen*, Cloud, Castle, Lake, translated by Peter Pertzov in collaboration with V. Nabokov, William Heinemann Ltd.

# Abstracts

## Painting Digital, Letting Go

James Faure Walker

### Abstract
There was a time when paint software really did look spectacular. Audiences at trade shows gasped at the silky airbrush of the Quantel Paintbox, even at a colour printer. It didn't matter what the image was, but the fact that you could scan and print a colour photo was amazing.

Among the many currents of contemporary art it no longer makes much sense to speak of 'computer art' as a special category. Painters know all about Photoshop and inkjet prints. A 'digital' artist now has to produce images that hold their own in a less protected exhibition space, alongside paintings, prints, photos, videos and installations. In the past, digital art was given an easy ride; it was a novelty, a niche art unpoliced by native commentators, hosted by cosy academic enclaves. If it was dismissed by the 'art world' this only reinforced the isolationist thinking, the sense that it was a secret underground whose day would come. It was actually riddled with clichés of geometric abstraction and ideas of art so naïve as to make a seasoned critic wince. Equally, paint software developed by imitating the look of 'natural media', appealing to a hobbyist market – all portraits and seascapes – where any post-modern irony would fall flat.

As a painter who has been integrating digital and painterly methods, the author of this paper has found it frustrating that connections are not made, that definitions and principles seem hard to grasp. This spectacular technology has not yet been properly absorbed. It could be time to let go of the idea that digital art is special just because it is digital. There remains the question of how to 'paint' with the technology, and this presentation will show some of the provisional answers that have emerged.

Keywords: computer art, digital painter.

## Microanalysis as a Means to Mediate Digital Arts

Matthias Weiss

### Abstract
It is an obvious fact that computer arts, and the fashionable 'software art', create their own recipients, disregarding the traditional art scene's public. Both the recipients and the art historians dealing with the relationship between computing and art are limited to a small number of specialists in a culture derived from the art and pop scene of the early 1990s.

Although there is an international history, one could ask what is really behind these works. Are programs like *Autoshop* (Ade Ward) or *Forkbomb* (Alex MacLean), to name two of the more prominent applications developed in recent years, something more than simply the dystopian misuse of programming language? Is there a formal and aesthetic motive? In this paper a thorough analysis within the realm of the micro-structure of each work will be presented, in order to discover the level of awareness of aesthetic problems, depicted via the means of programming language and programming itself as an artistic practice.

Furthermore it will be argued that contemporary practitioners do not quote, recall or reflect earlier explorations and practice in computer arts. One of the intentions of this paper is to close a 'short circuit' between current and past investigations, with close consideration given to individual works of art.

Finally, this paper intends to demonstrate that computer arts, historically and currently, are able to maintain a new role in the field of New Media arts, which should be taken seriously by art history in a classic manner but with a change in skills. Microanalysis of code is not a usual practice, but in order to uncover the type of relationship that exists between the arts and computer arts, this method is absolutely necessary. As will be shown in this paper.

Keywords: computer art, description, microanalysis.

## Indexed Lights

### Pierre R. Auboiron

### Abstract
'The proper artistic response to digital technology is to embrace it as a new window on everything that's eternally human, and to use it with passion, wisdom, fearlessness and joy.' (Ralph Lombreglia)

We live immersed in a global visual cacophony. Visual Culture is here and now, born of technological and scientific advances. Neither the hegemony of visuality, nor the role played by computers in its affirmation, need now be proved.

Since their emergence, digital technologies have fascinated many contemporary artists, although most pounce on these new and promising tools in an ill-considered way. Their productions thereby generally denote a manifest misunderstanding of digital issues. However some artists have a more considered approach to computers. An obvious example is the current practice of lighting public buildings using digital technology, a collaboration between artist and architect.

The first section of this paper outlines two artistic partnerships, each between an architect and a light designer working on a new approach to light. The partnerships are between Toyo Ito & Kaoru Mende in Japan and Jean Nouvel & Yann Kersalé in France. Using very complex lighting systems made of captors and computers, they can materialise and visualise surrounding 'natural' phenomena like noises, human activity, draughts and the current of a river on the buildings themselves. Thereby

they intend to make buildings fit back into their historical and socio-geographical environment.

The second section discusses in detail this novel social or environmental indexation of light. Using computers to make concepts and aspects of our everyday life visible and more tangible, these artists fight against the lack of interpersonal communication in today's urban life. Computers allow artists to materialise phenomena we can no longer perceive because we have developed our visual sense to the detriment of our other senses.

The central argument of this paper could be summarised by this quote by Wyndham Lewis: 'The artist is always engaged in writing a detailed history of the future because he is the only person aware of the nature of the present'. It shows that, with the benefit of hindsight, computers can help us live here and now instead of throwing us into a frantic individual rush to the future. This allows us to moderate the very widespread idea that computers are synonymous with cold and sanitised individuality.

Keywords: urban light art, digital technology, Yann Kersalé, Toyo Ito, Kaoru Mende.

## A Computer in the Art Room

Catherine Mason

**Abstract**
This paper introduces a little-recorded aspect of British arts education – the role played by educational institutions in the 1960s and 1970s in fostering computer arts.

The influence of 'basic design', a new type of art education influenced by Bauhaus concepts, can be traced through art schools from its inception in the 1950s, with artists informed by cybernetics, through the 1960s with artists working in programmatic ways, to artists who actually used computers by the 1970s. Victor Pasmore and Richard Hamilton's Basic Design Course was set up in 1953 at King's College, Durham University (at Newcastle upon Tyne). Roy Ascot's Ground Course was created at Ealing Art School in 1961 and subsequently at Ipswich Civic College. From there, Stroud Cornock went on to found Media Handling in 1968 at Leicester Polytechnic, with Cornock's student Stephen Scrivener among the first cohort at the Department of Experiment set up by systems artist Malcolm Hughes at the Slade School of Fine Art in 1972.

The creation of the polytechnics from the late 1960s onward, concentrated expensive resources into larger multi-disciplinary centres. In a number of institutions, the result was that artists had the opportunity to access expensive and specialist computer equipment and technical expertise (generally belonging to science or maths departments) for the first time.

Examples from a number of centres identified to date presented and the work created, equipment used and funding issues described. These include Coventry

School of Art (in the process of becoming Lanchester Polytechnic), which produced the first computer animation created in a British art school, Hornsey School of Art (subsequently Middlesex Polytechnic), which produced one of the first packages for artists, PICASO (Picture Computer Algorithms Sub-routine Orientated) and the Institute of Computer Science, where Tony Pritchett created the *Flexipede* in 1967 – the first computer-animated film in Britain.

Keywords: art education in Britain, Slade School of Art, computer arts, 1960s–1970s.

## Learning Resources for Teaching History of Art in Higher Education

### Jutta Vinzent

### Abstract

This paper evaluates different learning resources for teaching Art History in higher education: the use of slides and digital images, ICT resources (Internet and intranet), as well as study trips to galleries and museums. The discussion of these resources is based on a three-hour module which was taught at the Department of History of Art, School of Historical Studies, University of Birmingham, over two terms to second-year undergraduates (joint honours) in 2001 and 2002. The author has found that learning is enhanced when resources require students' active involvement and when students live and study together. She also draws attention to the technological change which requires the revision of students' IT skills, the improvement of departmental provision of ICT and tutors' increase in IT knowledge. An appendix lists useful websites for the study of History of Art.

Keywords: Art History, e-learning, e-resources, ICT.

## Sourcing the Index: Iconography and its Debt to Photography

### Colum Hourihane

### Abstract

This paper looks at the recent history of the Index of Christian Art as it faces the one hundredth anniversary of its foundation. The Index is at a critical stage in its development – with a large paper archive of text and images that are in need of digitisation and updating, it has had to change and extend the aims of the founder to build on current technology while at the same time realizing the value of past practices.

The Index has also had to adapt to current and immediate demands to make its resources available on the Internet. Policies and procedures have changed and the past has been built upon to create for the future. Now the largest archive of medieval art on the Internet, its acquisitions policy, for example, has altered significantly within the last five years. No longer the passive synthesis of published material, it has now actively taken on the role of publisher and much of the new material in the archive has never before been seen. It has also had to respond to new fields of study

such as Coptic and Islamic art that have been driven by worldwide research and publication but which have previously remained on the fringes.

The Index has had a pivotal role in determining iconographical research throughout its history and as it faces the future this role has to be re-evaluated in the light of the impact of new technology and initiatives.

Keywords: Index of Christian Art, Charles Rufus Morey, digitisation.

## The Medium was the Method: Photography and Iconography at the Index of Christian Art

Andrew E. Hershberger

### Abstract

The Index of Christian Art is a well-known collection of over 200,000 photographs with corresponding iconographical text cards, an early form of hybrid media now being translated into digital formats, all created for their use and value in art historical investigations. This paper examines the theory and practice behind the production of the photographs and text cards in the Index during two periods, focusing on the time when the Index began in the early twentieth century, and then speculating on how or whether that period has been transformed by the digital present.

In a recent history of the Index, Isa Ragusa claims that 'there was no model for the method of study of iconography that [Charles Rufus] Morey had in mind' when he founded the Index in 1917. With regard to the practice of art history then and now, Ragusa's claim is not entirely correct. Instead, it is argued that the medium of photography itself was the model for iconography during the first period of the Index's existence. What then does that mean for the digital moment the Index is in now? Is the new medium, the Internet and digital technology, likewise a model for iconography today at the Index?

Keywords: Index of Christian Art, iconography, photography, photographic objectivity.

## The Good, the Bad and the Accessible: Thirty Years of Using New Technologies in BIAD Archives

Sian Everitt

### Abstract

This paper reflects upon the use of new technologies in BIAD Archives over the past 30 years. BIAD Archives holds the archives and collections of Birmingham Institute of Art & Design (BIAD), a faculty of the University of Central England (UCE). BIAD Archives is a specialist repository that holds over twenty separate archives and collections, covering the fields of art and design education, museology and public art. The collections range in size from under 50 to over 40,000 items

and contain a mix of paper documents and books as well as artworks, photographs and artefacts.

BIAD Archives had been effectively closed to researchers for over twenty years. Despite the lengthy period of inaction, recent developments have been built on past experience. The original automated access system to the collections was developed in 1974, and is now fondly remembered as the 'Jiggling Box'. In 1987 a catalogue to one of the collections was created as a Strix database, which unfortunately lacked a digital preservation or migration strategy. More recently, in 2001, a Microsoft Access catalogue database was developed in an attempt to overcome the incompatibilities in archival and museum collection management and cataloguing standards.

Recently awakened in a digital age, a strategic approach has also been taken to utilizing collaborative regional and national digital initiatives to increase access to BIAD Archives. This has included collection-level descriptions, the creation of digital catalogue records, images and surrogates and the almost inevitable website. Currently plans are in development to adopt a user-centred design process in the creation of an online catalogue.

This paper considers the successes and the disappointments of 30 years of initiative and collaboration. It comments on the lessons learned in trying to harness the potential of computers to manage and interpret diverse collections.

Keywords: Birmingham Institute of Art and Design Archives, digitisation.

## Object Information at the Victoria and Albert Museum: Successes and Failures in Web Delivery

Melanie Rowntree

### Abstract
With the V&A's first database-driven, object information interface on the Web entering its second year of delivery, now seems the perfect time to review its history of presenting collections data online. This focuses on four projects, looking at the planning and implementation of content creation, the resultant successes and failures and the potential for the re-purposing of data.

The four initiatives under review are: *Images Online*, the V&A's first attempt at Web delivery of its collections data; the *British Galleries Online* (*BGO*), a gallery interactive database developed for the renovated British Galleries; *Exploring Photography*, which began in 1998 as an interactive kiosk in the Cannon Photography Gallery that was put on the Web in April 2003; and, finally, *Access to Images* (*AtoI*), the most recent initiative, which delivers content for around 17,000 objects directly from the Museum's Collections Information System (CIS).

Both *Images Online* and *Exploring Photography* were locked into the V&A website as static webpages, thus restricting any data re-purposing. The search capability of both was also severely limited. Unfortunately, the implications were not considered during the planning of content creation. The *BGO* also suffers from limited re-use

of the content as its data sits in a purpose-built project database, rather than the V&A's primary object database. By learning from these three projects, staff, planning *Access to Images*, were careful that data be derived from primary source systems and delivered to a Web interface with full search capabilities. With *AtoI* there is no problem with re-purposing data as it is refreshed from the live system.

There are, however, lessons to be learned for the future development of *AtoI*. Although good practice in content creation and data re-purposing has created a solid foundation, the current interface must serve varied users with differing needs and experiences. Both *BGO* and *Exploring Photography* provide extensive layers of contextual information to users as well as personal guided tours that help mediate the information for the user. They contain many ingredients which will be vital in making *AtoI* intellectually engaging and fun to use. In combining lessons learned from all four projects, the Museum may define a path for ongoing improvements to Web presentation of its collections data.

Keywords: Victoria and Albert Museum, London, online collections.

## This is the Modern World: Collaborating with ARTstor

### Vickie O'Riordan

### Abstract
January 2002 marked the beginning of a valuable collaboration between the Andrew W. Mellon Foundation and the University of California, San Diego Libraries. A substantial grant from the Mellon Foundation gave the UCSD Libraries slide collection the opportunity and capability to contribute a significant amount of images and associated cataloguing data to ARTstor.

The UCSD slide collection, started in the early 1970s, contains 250,000 slides, the majority created from copy-stand photography. A library resource, the slide collection is used campus-wide by UCSD faculty and students. It contains a robust collection of art images from a wide range of periods and cultures, as well as a substantial number of images from the humanities and social sciences. When the slide collection went online in the mid-1980s, the decision was made to create a full catalogue record for each slide complete with subject headings. In the early 1990s the slide records were moved into the UCSD Library catalogue and mapped to MARC.

This paper covers the following four areas:

- Early decisions made by the UCSD slide collection that facilitated its inclusion in ARTstor;

- The work and planning required to digitise over 200,000 slides from a continuously used university slide collection;

- Lessons learned working with the ARTstor metadata group and the effect this had on continuing image cataloguing at UCSD;

- Finally, discoveries made while working with UCSD faculty and students as ARTstor beta testers for the past academic year in terms of educational implications and classroom readiness. The complexity and scale of this partnership required considerable planning and utilised a wide range of resources. The result is a successful community resource for sharing images within an expanded educational audience.

Keywords: slide collections, digitisation, collaboration, University of California, San Diego (UCSD) Arts Libraries, ARTStor.

# Towards a Semantic Web: The Role of Ontologies in the Literary Domain

## Luciana Bordoni

### Abstract
The application of ontological resources in the cultural domain can offer a useful means to handle the ambiguity of natural languages and the need for a finer discrimination of meaning in written description of digital products on one hand the retrieval of relevant information on the other.

Archives, museums and libraries are making enormous contributions to the amount of information on the Internet through the digitisation and online publication of their photographic, audio, film and video collections. Currently, there is a great deal of interest in the development of ontologies to facilitate knowledge-sharing in general and database integration in particular. Studies on ontologies are receiving a growing attention owing to the development of Web services. The Semantic Web represents a new direction in the area of knowledge representation as the attempt to make information, texts and knowledge shareable throughout different Web applications. From the point of view of language and text processing, the Semantic Web represents a challenge in several directions, including linguistic capabilities. Ontologies are often seen as basic building blocks for the Semantic Web, as they provide a reusable piece of knowledge about a specific domain. This paper explores the issue of ontology in the literary research; an experiment demonstrates how the application of the WordNet ontology to disambiguation of the word sense can help in understanding of a literary phenomenon.

Keywords: ontological resources, cultural domain, Semantic Web, information integration, information retrieval.

# CHArt – Computers and the History of Art

Computers and the History of Art looks at the application of digital technology to visual culture, particularly in relation to the study of the history of art, the work of museums and galleries, and of archives and libraries, as well as the broader issues of visual media.

CHArt was established in 1985 by art and design historians who were also computer enthusiasts. CHArt's largely university-based membership was soon augmented by members from museums and art galleries, as well as individuals involved in the management of visual and textual archives and libraries relevant to the subject. More recently CHArt has become a forum for the exchange of ideas concerned with all aspects of visual culture. CHArt continues to promote this activity in a number of ways. An annual two-day conference explores topical issues.

The group maintains a website, **www.chart.ac.uk**, which provides information about activities relevant to its members. Among its activities CHArt has run a journal, now replaced by the Yearbook. CHArt also publishes Conference Proceedings and an online Newsletter and hosts an e-mail discussion group. Since 2000, conference proceedings have been available on the CHArt website. CHArt also sponsors the World Wide Web Virtual Library for the History of Art and has initiated a project concerned with documenting early digital applications in the history of art. CHArt's Annual Conference is usually held in the autumn and focuses on current developments in the field. Recent conferences have included:

2000:   Moving the Image: Visual Culture and the New Millennium, Courtauld Institute of Art, University of London.

2001:   Digital Art History. A Subject in Transition, British Academy, London.

2002:   Digital Art History? Exploring Practice in a Network Society, British Academy, London.

2003:   Convergent Practices: New Approaches to Art and Visual Culture, Birkbeck College, London.

2004:   Futures Past: Twenty Years of Arts Computing, Birkbeck College, London.

2005:   Theory and Practice, British Academy, London.

## How to Become a Member of CHArt

CHArt Membership is open to everyone who has an interest in the use of digital technology for the study and preservation of works of art and visual culture. To join, please complete the online application form on our website: www.chart.ac.uk and send it to:

CHArt, Centre for Computing in the Humanities, King's College, Kay House, 7 Arundel Street, London WC2R 3DX. Tel: +44 (0)20 7848 2013, Fax: +44 (0)20 7848 2980, www.chart.ac.uk, membership@chart.ac.uk.

## Membership Information for 2006

CHArt membership is £15.00 and is valid for a calendar year. It includes a reduced rate for our annual conference. Student Membership includes a reduced student rate for our annual conference. Institutional Membership includes a reduced conference rate for up to three delegates from your institution and costs £35.00.

Please visit www.chart.ac.uk for further information.

# Guidelines for Submitting Papers for the CHArt Yearbook

## 1. Texts

Papers should be submitted in hard copy and in electronic PC format, preferably in Word or RTF and should be of no more than 5000 words. Please submit your paper to yearbook@chart.ac.uk. Please also submit a brief biography of no more than 75 words. Texts are accepted only in English.

## 2. Conditions

Submission of a paper for publication in the CHArt Yearbook will be taken to imply that it represents original work not previously published, that it is not being considered elsewhere for publication, and that if accepted for publication it will not be published elsewhere in the same form, in any language, without the consent of the editors and publishers. It is a condition of acceptance by the editor of a paper for publication that CHArt acquires automatically the copyright of the text throughout the world. However, the author shall retain a perpetual, non-exclusive licence to publish and distribute the paper under the condition that proper credit is given to the original published article.

## 3. Permissions

It is the responsibility of the contributor to obtain written permission for quotations where necessary and for the reprinting of illustrations or tables from material protected by copyright (published or unpublished). No payment can be made for obtaining any copyright required in order to use quotations or illustrations. It is the responsibility of the contributor to obtain written permission for the use of any illustration which remains in copyright. The contributor must supply details of any acknowledgement that may need to be placed in captions.

## 4. Illustrations

All illustrations should be designated as 'Fig. 1' etc. and be numbered with consecutive Arabic numerals. Each illustration should have a descriptive caption and should be mentioned in the text. Indication of the approximate position for each illustration in the text should be given.

Illustrations should not normally exceed more than six per article. Please submit illustrations in electronic format, preferably as 300 dpi TIFF files.

## 5. References and Notes

References and notes are indicated in the text by consecutive superior Arabic numerals (without parentheses). Please present all references and notes as endnotes

in numerical order. In multi-author references, the first six authors' names should be listed in full, then 'et al.' may be used.

## References to Books

Author's name and initials (year of publication), [year first published, if different], *full title*, place of publication: publisher, page numbers.

Berners-Lee, T. (1999), *Weaving the Web*, San Francisco: Harpers, p. 23.

Lasko, P. [1972], *Ars Sacra*, London: Yale (1994).

## References to Essays/Articles in a Book

Author's name and initials (year of publication), [year first published, if different], 'title of article', *title of book in full*, editor's name, editor's initials (ed.) or (eds) if plural, series number (if any), place of publication: publisher, volume, page numbers.

Smith, J. C. (1981), 'The Kings and Queens', *The History Journal*, Smith, P. (ed.), London, Little Brown, pp. 200–28.

## References to Articles/Essays in a Journal

Author's name and initials, (year of publication), 'title of essay', *title of journal*, volume number: issue number, page numbers.

Jones, T. A. (1990), 'The British Coin', *British History*, 19:1, pp. 98–121.

## References to Essays/Articles in Conference Proceedings

Author's name and initials, (year of publication), 'title of essay', *title of proceedings*, venue and date of conference, place of publication, page numbers.

Grindley, N. (1999), 'The Courtauld Gallery CD Project', *Computing and Visual Culture. Proceedings of the Fourteenth Annual CHArt Conference*, Victoria and Albert Museum, 24–25 September 1998, London, pp. 131–140.

Authors must check that reference details are correct and complete; otherwise the references cannot be used. As a final check, please make sure that the references accord with the citings in the text.

## References to Online Publications

References to online publications should include the URL and the date last accessed.

/